Acknowledgements

Alison Kelly, Headteacher, Stuart Road Primary School Plymouth for permission to include in chapter 4 two examples of cross-curricular planning she has used in her own school.

The Headteachers of the following schools for permission to include in this publication examples of work by children in their schools.

Ashburton Primary School
Barton Infants School, Torquay
Basset's Farm Primary School, Exmouth
Beaford Primary School
Bridgetown C of E Primary School, Totnes
Brixington Junior School, Exmouth
Broadclyst Primary School
Cowick First School, Exeter
Dalwood Primary School, Axminster
Decoy Primary School, Newton Abbot
Ellacombe Primary School, Torquay
Exeter Road Primary School, Exmouth
Exwick Middle School, Exeter
Heathcoat First School, Tiverton
Heathcoat Middle School, Tiverton
Littletown Primary School, Honiton
Newport Primary School, Barnstaple
Oldway Primary School, Paignton
Plymtree C of E Primary School
Saint John's RC First School, Tiverton
Saint Joseph's RC Primary School, Newton Abbot
Saint Michael's C of E Primary School, Kingsteignton
Saint Nicholas RC Combined School, Exeter
Sherwell Valley Primary School, Torquay
Southway Infants School, Plymouth
Stoke Hill First School, Exeter
Stoke Hill Middle School, Exeter
Stokenham Primary School
Stowford Primary School, Ivybridge
Stuart Road Primary School, Plymouth
Thornbury Primary School, Plymouth
Tipton St John Primary School
West Hill Primary School, Ottery St Mary
Widey Court Primary School, Plymouth
Wilcombe Primary School, Tiverton
Woodfield Junior School, Plymouth
Woodford Primary School, Plympton

4

Contents

OLIVER & BOYD

PRIMARY ART

Principles and practice in art

Robert Clement
and Shirley Page

Oliver & Boyd
An imprint of Longman Group UK Ltd
Longman House, Burnt Mill, Harlow, Essex CM20 2JE,
England and associated companies throughout the world.

First published 1992
ISBN 0 050 05082 6
Printed in Hong Kong
SK/01

Designed by Roger Walton Studio

The publisher's policy is to use paper
manufactured from sustainable forests.

Introduction

PREFACE

This series of books and the supporting resources that make up 'Primary Art' have been put together to give teachers in primary schools support with the introduction of the National Curriculum in Art. Although each of these books is free standing and will provide help for teaching particular aspects of Art and Design, they have been designed to be complementary and, together, will give comprehensive guidance for teaching Art in the National Curriculum.

In *Art for Ages 5 to 14*, published by the Department of Education and Science in August 1991, the Art Working Group identified a number of factors that are common to those primary schools where there is consistently good practice in the teaching of Art and Design.

'The head and teachers share aims and objectives, often expressed in a clearly stated policy document.'

'The continuity provided by individual teachers planning within that agreed policy is an important factor.'

'The staff give clear guidance, where appropriate, having analysed the steps that pupils need to take to gain a skill or understand a concept.'

There is balance between 'the activity of making art, craft and design with opportunities for pupils to reflect upon and discuss their own work and the work of others'.

Children's drawing abilities are developed 'to the point where they are at ease using drawing as a tool; for example, to aid thinking'.

Children develop 'confidence, value and pleasure in making art, craft and design'.

The overall quality of work in Art and Design in any primary school is determined by these kinds of factors and by the way that teachers within that school work together to put in place an art curriculum that matches the coherence that the National Curriculum has brought to other subjects. We hope that this series of books will help teachers to meet the

challenge of the National Curriculum in Art and to put in place in their own schools the consistency and quality of practice that will best serve the abilities and needs of their pupils.

In this work we have drawn extensively upon examples of good practice in the teaching of Art and Design from a wide variety of primary schools, ranging from small village schools to large schools serving urban communities. We wish to acknowledge the important contribution that the teachers in these schools have made to our own work and thinking in art education. The quality of children's work in Art and Design and its relevance and meaning to them rests upon the enthusiasm and commitment that teachers like these bring daily to their work in schools.

Bob Clement and Shirley Page

'Primary Art' consists of the following titles:

PRINCIPLES AND PRACTICE IN ART

This book describes those general principles that determine the teaching of Art and Design: its aims and objectives, Attainment Targets, the development of image making, structure and sequence, placing work in context, cross-curricular issues, assessment and appraisal.

KNOWLEDGE AND UNDERSTANDING IN ART

This book examines the place of critical and contextual studies in Art and Design: how to use works of art and design to support children in their making of images and artefacts, how the study of works of art can generate reflection and appraisal, how children can be helped to understand the relationship between their own work and that of other artists working in different times and cultures.

INVESTIGATING AND MAKING IN ART

Part I 'Investigating' describes how children can develop and use a range of drawing skills to describe and investigate their experience and how these can be used in association with a wide range of resources to develop ideas and concepts.

Part 2 'Making' provides detailed guidance for the organisation and teaching of a wide range of art and design disciplines, including painting and drawing; two- and three-dimensional design and it provides a structure for the development of children's visual language and allows them to reflect upon their making.

The purpose of Art and Design in the primary school curriculum

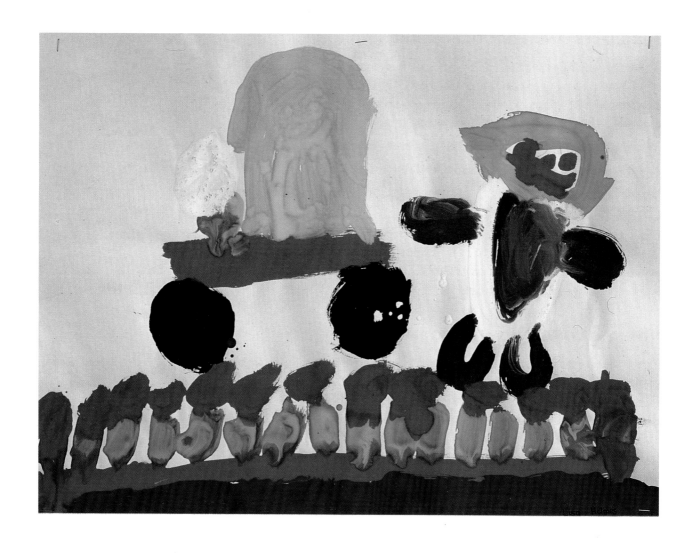

THE PLACE OF ART IN SCHOOLS

The introduction of the National Curriculum in Art in September 1992 celebrates by almost 100 years the anniversary of the beginning of art education in our schools under the title 'The National Course of Instruction in Drawing'. One hundred years ago, art and handwork were regarded as being essential disciplines for the training of the hand and eye of those children who were to become the artisans of the future.

In that 100 years, the purpose and function of art teaching in schools has undergone some significant changes. It has been subject to considerable debate and conflict over the contribution that it might make to the general education of children.

Fifty years ago, with the introduction of the 1944 Education Act, teachers of Art and Design in secondary schools were divided in their views between those who saw the subject as being predominantly a vehicle for personal expression and emotion and those who regarded it as a collection of art and craft disciplines to be learnt and applied.

In primary schools, there has been a wide variety of practice in the teaching of Art and Design, with teachers having different views as to its value and purpose for children. At one end of the scale, there have been teachers who because of their own love of the subject have taught it well and with conviction but in isolation from the rest of the curriculum: Art has been something special and different to other subjects taught in the school. At the other end of the scale, there have been those who have seen Art only as a service agent to other subjects and as a means to illustrate topic and written work.

There has been a similar conflict of views about how Art and Design should be taught to children in primary schools. Some teachers have held firmly to the view that children should be taught Art and Design through its techniques and disciplines and have adopted a methodological approach to teaching such skills as painting and claywork. On the other hand, there have been many primary school teachers who have genuinely believed that 'you can't teach art', that ability in Art is somehow inherent in children and that pupils are, in any case, naturally and spontaneously creative and will make art if left to their own devices.

Where such conflicting views about the purpose of Art and its teaching exist in the same school, it is confusing for the children and unlikely to generate an art and design curriculum that has continuity or coherence for them. It is for this reason that the proposals for a National Curriculum in Art should be welcomed. In its best practice, the teaching of Art and Design in our primary schools may be seen to have reconciled some of these past differences and to have established a purposeful place and model for the teaching of the National Curriculum in Art.

The proposals from the Secretary of State for Education for Art in the National Curriculum – *Art for Ages 5 to 14* – describe the nature and scope of the subject as follows:

'Art is one of the subjects in schools concerned with visual

communication, aesthetic sensibility, sensory perception, emotional and intellectual development, physical competence and critical judgement. Its particular contribution is concerned with:

● developing imagination and creativity;

● observation and the recording of visual images, and through this, the expression of ideas and feelings;

● the interpretation of visual images;

● the transformation of materials into images and objects;

● the skills of planning and visualisation;

● the intuitive, as well as the logical, processes of designing;

● the study of the work of artists, craftworkers and designers.'

The Attainment Targets and Programmes of Study for Art in the National Curriculum provide a framework for teachers to implement those proposals – that children should be taught to use, understand and make images and artefacts for a variety of purposes.

In the vast majority of our primary schools, Art and Design is taught to children by the class teacher alongside all those other subjects required by the National Curriculum. Like any other subject, Art and Design has its own disciplines and content, and these have to be observed; however, much of its practice takes place in conjunction with other subjects. In secondary schools, Art can be taught as a specialist subject and though there may be some reference to and structured overlap with other subjects, its purpose is largely self-contained within the subject discipline. In the teaching of Art and Design in primary schools at **Key Stage 1** and **Key Stage 2** the contribution that Art makes to children's learning has to be both valued in its own right and used constructively in association with the teaching of other subjects. This use of art and design disciplines to extend and enrich the teaching of other subjects is characteristic of the best practice in our primary schools, where the skills of making and communicating ideas through images are central to the curriculum.

In the process of putting the National Curriculum in place it has already become evident that the careful attention to subject association and overlap is essential to its delivery. In planning for the way in which the Art curriculum will be put in place, you will need to consider both the purpose of the subject and its function in relation to other subjects.

ART AND DESIGN AT WORK IN THE CLASSROOM

The experience of learning how to draw and paint and how to design and make images or artefacts is valuable to children in its own right. Through these disciplines and processes children acquire important communication and making skills that make a significant contribution to their learning in other areas of the primary school curriculum.

Drawing and painting

In the early years of schooling, children's work in drawing and painting plays an important part in their development of language. In the Reception class and in Year 1, it will become the focus for much of their naming and describing and knowing about the world. The simple language of symbols that they use in their first drawings and paintings enables them to 'tell stories' and to describe and comment upon their experiences more freely than they can through the more formal means of writing. In this way and through their work in Art, they are able to make significant statements which both encourage and enrich their use of language.

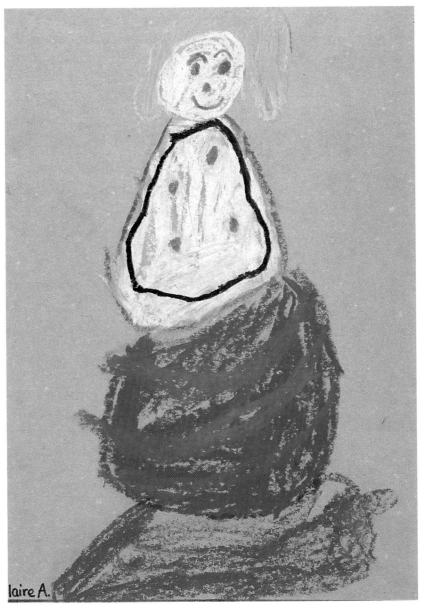

1.1 MY GRANDMOTHER
Reception
Crayon

1.2 ME IN THE PARK
Reception
Tempera

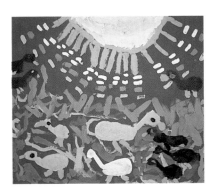

1.3 DUCKS SWIMMING ON THE CANAL
Year 1
Tempera

Making images and artefacts

Children's work with materials will begin with:

● sand and water play;

● experiment and play with constructional toys and materials;

● exploration of the marks and shapes that will grow from using drawing materials and paint.

In working with materials, in learning how to shape and form both two and three dimensionally, children will begin to obtain those handling and motor skills that will form the basis for both craftworkship and technical accomplishment.

In acquiring the skills to transform materials into images and objects and to plan and visualise the possibilities in designing and making, children are working at that cutting edge between Art and Technology which is so essential to the successful implementation of the Programmes of Study for Technology in **Key Stage 1** and **Key Stage 2** (see figures 1.4 to 1.9).

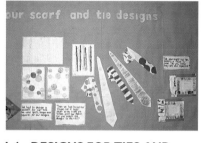

1.4 DESIGNS FOR TIES AND SCARVES
Year 4
Fabric

1.5 CHURCH INTERIOR
Year 5
Batik

1.6 STUDIES OF THE LOCAL BRIDGE
Year 5
Pencil and watercolour

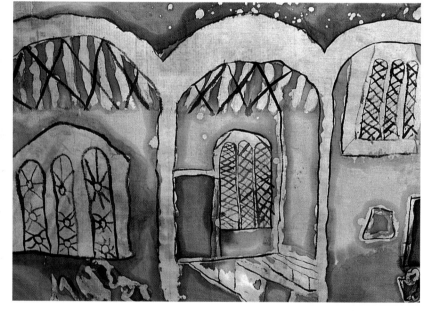

1.7 BRIDGE RELIEF
Year 5
Ceramic

1.8 BRIDGE COLLAGE
Year 5
Embroidery

1.9 STUDIES FOR FLYING MACHINES
Year 6
Pencil and biro
Based on the study of Leonardo da Vinci's sketchbooks

Communicating

Learning to observe carefully and sensitively and to draw with some competence is essential to children's work in Art. It is also an important means by which they are enabled to investigate and respond to evidence of the appearance and structure of the natural and made world that is so important to their work in Science and Humanities. They need to be taught to observe and draw with competence to acquire the following skills in support of their work across the curriculum:

● to describe and record the appearance and structure of the natural and made world accurately and sensitively (figures 1.16 to 1.20);

● to compare and analyse the structure and appearance of familiar things within the environment (figures 1.21 and 1.22);

● to tell stories and convey information visually (figures 1.23 and 1.24);

● to communicate and express ideas that are personal and individual to them (figures 1.25 and 1.26).

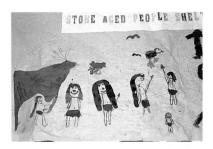

1.10 STONE AGE PEOPLE
Year 2
Mixed media

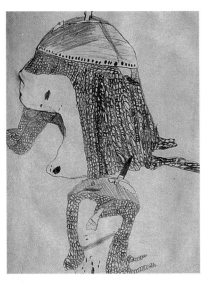

1.11 HELMET STUDIES
Year 3
Pencil

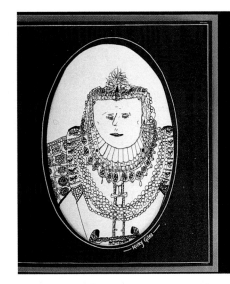

1.12 ELIZABETHAN MINIATURES
Year 5
Fibre pen

1.13 STUDYING DISTORTION IN A LENS
Year 4

1.14 STUDIES OF AN ORANGE DECAYING
Year 5
Watercolour

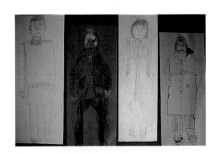

1.15 DRESSED FOR DIFFERENT KINDS OF WEATHER
Year 5
Various media

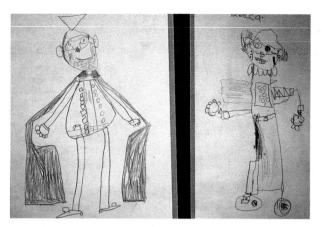

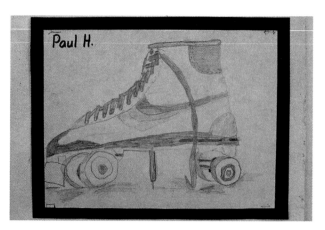

1.16 STUDIES OF PUPPETS
Year 2
Pencil

1.17 SKATE BOOT
Year 4
Pencil

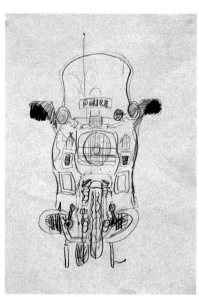

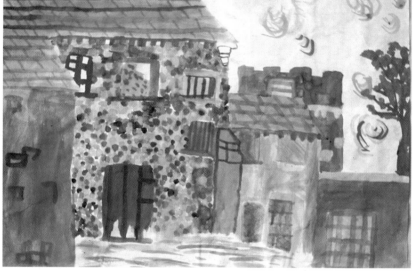

1.18 POLICE MOTORCYCLE
Year 5
Biro

**1.19 BARNS NEAR THE
SCHOOL**
Year 4
Watercolour

1.20 FEATHER STUDY
Year 5
Chalks and pastel

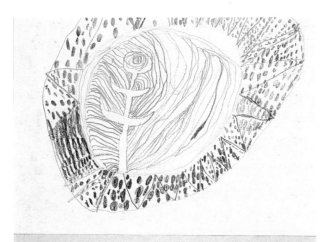

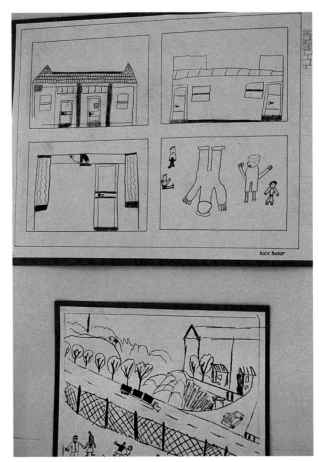

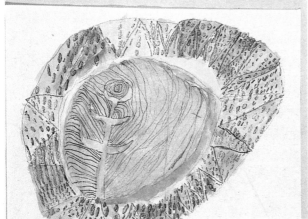

1.21 CABBAGE PATTERNS
Year 4
Pencil and watercolour

1.22 PATTERNS ROUND THE SCHOOL
Year 3
Microliner

1.23 POSTMAN PAT'S JOURNEY
Reception
Crayon

1.24 MY HORSE
Year 6
Felt pen and pencil

1.25 NIGHT CREATURE
Year 3
Tempera

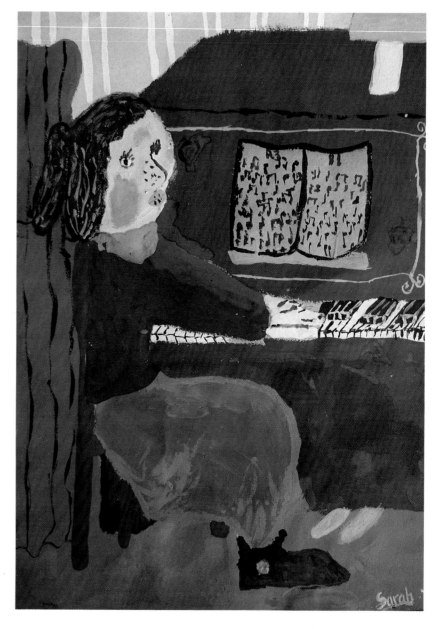

1.26 ME PLAYING THE PIANO
Year 5
Tempera

In making and using images for different purposes children will become visually literate in much the same way that they acquire literacy through practice in the use of descriptive, transactional and expressive language. Children need to be visually literate to function effectively in a society where visual images enter our lives through the mass media – publications, newspapers, film, television – where so much information is presented to us through visual means in our everyday environment.

Children's work in making images and artefacts can play an important part in the development of their ability to appraise and reflect upon the appearance and design of those things that are part of their social and cultural environment. They can come to a better understanding of the relationship between their own school work and that in the world outside school through the use of evidence of the work of artists, designers and craftworkers, in association with their own work.

In framing ideas visually, children are able to explore and communicate their responses to and ideas about both the real world of their surroundings and of the world within themselves. In making Art, children are able to give form to their ideas and feelings about the world and to make these evident to others.

This general description of the purpose for work in Art in primary schools is developed in more detail in Chapters 4 and 5.

THE AIMS FOR ART IN THE NATIONAL CURRICULUM

In *Art for Ages 5 to 14* the aims for Art in the National Curriculum are described as follows:

'From the ages 5 to 14, art education should:

- enable pupils to become visually literate: to use and understand art as a form of tactile communication and to have confidence and competence in reading and evaluating visual images and artefacts

- develop particular creative and technical skills so that ideas can be realised and artefacts produced

- develop pupils' aesthetic sensibilities and enable them to make informed judgements about art

- develop pupils' design capability

- develop pupils' capacity for imaginative and original thought and experimentation

- develop pupils' capacity to learn about and observe the world in which they live

- develop pupils' ability to articulate and communicate ideas, opinions and feelings about their own work, and that of others

- develop pupils' ability to value the contribution made by artists, craftworkers and designers and to respond thoughtfully, critically and imaginatively to ideas, images and objects of many kinds and from many cultures.

The Attainment Targets that encapsulate these aims and the Programmes of Study that will provide a framework for their delivery are described in detail in Chapter 3.

2 The development of children's image making

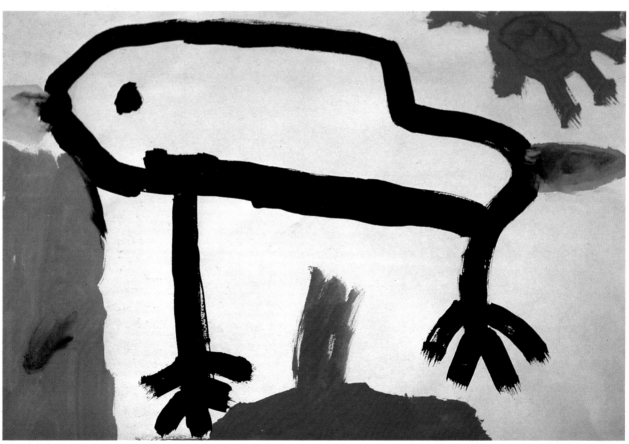

2.1 BIRD
Reception
Tempera

THE CHANGING PATTERN OF CHILDREN'S IMAGE MAKING

During their first seven years of schooling, children's perceptions of their world and the way in which they make images in response to those perceptions change significantly. A five-year-old child sees the world very differently to a child of nine. Even in **Key Stage 1** many children will progress from scribbling, to making simple symbolic drawings, to drawing descriptively. In order to help children to make sense of their observations of the environment and to support them in their image making, you need to understand how and why these changes take place. Such understanding will have considerable bearing upon the content of your teaching of Art and Design and the kind of tasks and projects that you present to children at different stages in their development.

All children go through a similar pattern of development in their making of images. They begin by scribbling and their first scribbles are simply maps of the movement made by the hand that is clutching the crayon. Children are soon able to control their scribbles and begin to make different marks and shapes.

When they are painting, they begin by 'playing' with the colour and enjoying its physical and sensual properties, discovering that colours will blend into each other and will run down the page. As they gain more control over their use of paint they will begin to make more controlled shapes and patterns.

2.2 SHOES
Year 1
Tempera

Quite naturally, children will begin to associate these shapes and symbols that they make in their early drawings and paintings with things that they see and enjoy in their everyday world. They will begin to 'name' their drawings and will identify them as 'my cat', 'my mum' or 'daddy's car'. Many children who have had good support at home or who have attended nursery classes or playgroups will arrive in the Reception class already confident in their making of these simple symbolic drawings: other children may still be in the early stage of scribbling.

This ability that children have to make symbolic drawings that stand for, or 'represent', their experiences has an important function for them in their early years of schooling. It provides for them a form of communication, or 'storytelling', that is more flexible and accessible to them than the formal language of the spoken or written word. This may be evident in the class diary of a child in Year 1, where there may be a considerable contrast between the halting written sentence that describes the most important event of the previous day and the lively drawing that extends and amplifies the written word. When the child's vocabulary is limited to a few hundred words, the making of a drawing may enable them to make more complex statements than words will allow. Making an image helps children in their thinking, in addition to helping them to name and describe their world and to respond to and enjoy its complexities.

Teachers working with children in their early years in school recognise

2.3 CHILD MAKING A PAINTING
Reception

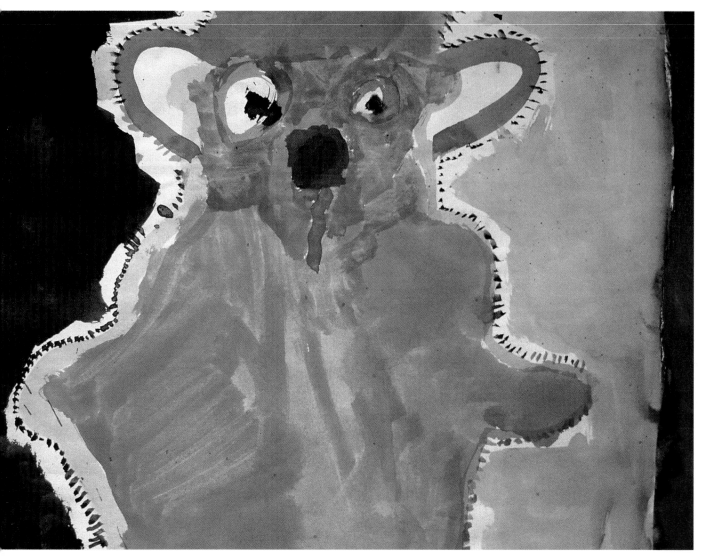

2.5 TEDDY BEAR
Year I
Tempera

2.4 BICYCLE
Reception
Pencil

that there is a close relationship between their work in Art and their development of language. Both art and language help the child to name and describe things and to tell stories, and therefore one means of communication supports the other. Sometimes the language will flow from the making of a drawing; at other times the drawing will accompany and grow with the storytelling or commentary.

Children's first drawings are generally concerned with everyday things of importance to them; for example, self, family, pets, possessions and special occasions such as birthday parties. At this early stage, children use drawings very freely. They are not limited by the conventions of representation and will cheerfully draw their experiences of the world: what they know and remember and think about it, as well as what they actually see around them. Their early acquisition of a range of simple symbols and shapes that 'stand' for the things they see and experience helps them to draw in this very flexible way.

In these early drawings, for example, children will use the circle to 'represent' many different things in one image. The circle will stand for the head, eyes, body, hands and feet in one drawing of a figure (see

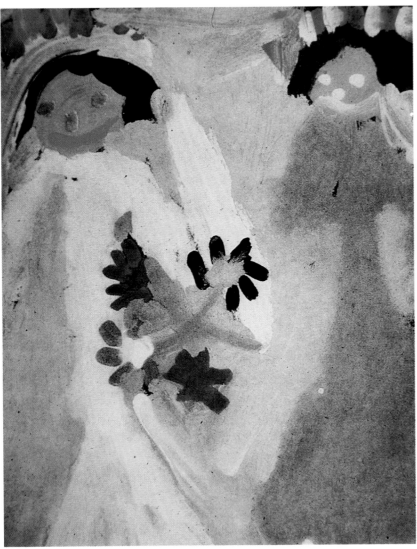

2.6 MY SISTER GETTING MARRIED
Year 2
Tempera

2.7 MUMMY HANGING OUT WASHING
Reception
Felt pens
The child has used the circle 'symbol' to represent different things within the picture.

figure 2.7). Variations of the same circle will also describe such features within the landscape as the sun, trees and flowers. All children use the same collection of shapes and symbols to 'represent' their house in their first drawings: a triangle for the roof upon a square, with a smaller square in each corner to represent the windows, and a central door.

Children are using these symbols in these early drawings to name and describe things and events that are important to them. They are not concerned about or confused by the differences between the images they make and the appearance of things in the real world. We frequently describe these early drawings as 'private' drawings because although the child will happily share them with parent or teacher, they are essentially a personal form of communication. In making the drawing the child is trying to make sense of or to celebrate his or her experiences. Children are coming to terms with a strange and exciting world by 'naming' it graphically.

In making symbolic drawings to tell their stories, children happily kaleidoscope time, space and scale in one image. They do not draw images as we might, from one fixed point of view in one moment of

2.8 GOING SHOPPING
Year 1
Tempera

time. All their early drawing are made from memory and imagination. A drawing of 'A day at the seaside' by a child in Year 1 will typically include several events taking place at different times; people in the painting will be smaller or larger depending upon their importance to the narrative and they will be placed according to the logic of the story – important people to the front of the painting and others in the corners. Because they are using symbols to represent their experience and are not constrained by the 'conventions' of representation, children are able at this stage to draw freely and flexibly. They are not daunted by any subject matter nor worried about whether things 'look right'. The images they make are consequently full of vitality and invention. It is not surprising that many professional artists have, over the years, attempted to recapture in their own work 'the innocent eye of the child'.

Because young children may make such marvellous and spontaneous images during their first two years in school – often with very little help from the teacher, other than as provider of audience, approval, materials and space – it is often assumed that they will continue to see and respond in this way beyond the point where it is no longer appropriate to them.

Children's perceptions of their world and the way in which they can make images in response to their experience does, however, go through some significant transition in **Key Stage 1** In these early years, much of the emotive drive to make images to convey their perceptions is provided by the fact that for many children image making gives them access to a language for storytelling and description that is richer than their spoken and written language. They can quite simply make more complex and satisfying statements through making images than they can in their oral and written work. Once they begin to gain confidence and skills in speaking and writing, then their need to use images to communicate their meaning begins to decline. The drawing that illustrates the entry in the class diary begins to decline in importance as the child gains mastery over the written word; it becomes a postscript to the written statement.

As they mature, children begin to develop the ability to see and respond to the world more objectively and more independently of their feelings and personal experience. They become increasingly aware of existing images and forms and their apparent authority: more conscious of the complexity of all those things that they can observe in the visual environment. They become conscious too of the complexity and detail of much of what they see and of the differences between the images that they make and those that surround them.

When children's image making is valued and they are given encouragement to use and make images as a means of storytelling, it is rare for them to complain that 'I can't draw' much before the end of **Key Stage 1** When they do complain, it is a certain sign that they are making that important transition towards wanting images to correspond in appearance to the complex and objective world about them. It is a crucial point

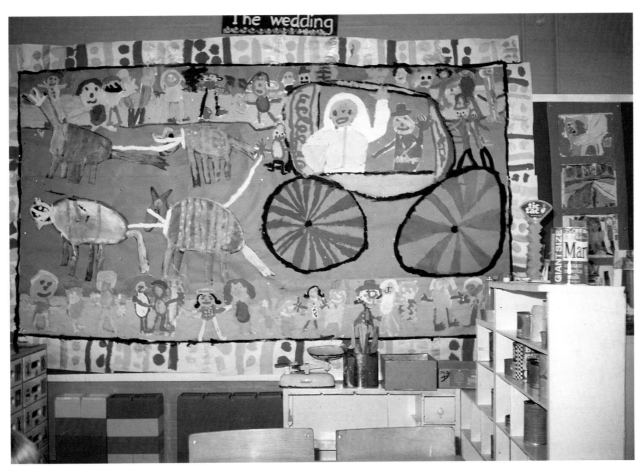

2.9 ROYAL WEDDING
Year 2
Group painting/collage

when the child recognises that the images he or she makes have public consequence as well as giving private satisfaction. Now they begin to relate their drawings to the objective appearance of things in the real world and to all those other images that surround them in pictures and photographs and in the media of film and television.

All children go through this transition from being happy and confident in making their personal and symbolic representations of the world, to being uncertain because they need to make more objective images that describe their observations and perceptions effectively to other people. Teachers can help children move from drawing symbolically towards drawing descriptively by recognising that this transition takes place and by providing pupils with opportunities to use both systems of drawing. The National Curriculum in Art recommends that children should make drawings from observation, memory and imagination from the start of their schooling.

At the age of five, children are quite capable of using their vocabulary of shapes and symbols to make both 'storytelling' and observed or 'careful looking' drawings. Children in a Reception class will respond to questioning about the appearance of teddy bears in their classroom by making simple descriptions of them in their drawings. How much they describe will depend upon how well the questioning focuses their attention upon the appearance and detail of the teddy bears. They will also resort cheerfully to drawing teddy bears symbolically when the task set

2.10 OLD TEDDY BEARS
Year 1
Microliner

Emma

2.11 OLD TEDDY BEARS
Year 1
Microliner

them is to tell a familiar story about teddy bears, such as 'The teddy bear's picnic'.

Children will cope well with their changing perceptions of the world and their need to make and use images for different purposes as they move through their schooling. Teachers should recognise that the making of images, like the use of language, has different purposes for children at different stages in their development.

In **Key Stage 1** children need to use images predominantly for two purposes: to tell stories about their personal view of the world and to recall and describe familiar things and events.

In **Key Stage 2** and well into **Key Stage 3** children need to make and use images for increasingly complex purposes. At this stage of their development, their image making is dominated by their need to use painting, drawing and three-dimensional modelling to comprehend better how the world works, what it looks like, how it is put together and how different things compare with each other.

As children acquire some confidence in their making of observational drawings and can describe the shapes, patterns and surfaces of familiar things with a variety of media, they are then able to begin to make more investigative drawings. They may begin by making comparisons between similar things, recording the way that things change as they grow, or analysing through drawing the way that made forms are constructed.

They will begin to use images not only to describe appearances, but also to explain the purpose and structure of those things they are investigating. This way of working in Art has parallels with the investigations they undertake in their work in Science and Technology, where the ability to collect and sort information visually and to pursue alternative solutions is essential. Where children are set appropriate tasks and challenges, they are quite capable of using different kinds of drawing systems to investigate the possibilities within a design task and communicate their findings effectively to others.

In **Key Stage 1**, the kind of images that children make is determined by their need to use images for visual storytelling and to begin to name and describe the world in which they live.

In **Key Stage 2**, the skills of description will be extended into investigation and analysis through their need to explain and understand, as well as describe their experiences. Although children are no longer able to use that flexible and symbolic system of drawing that serves younger children so well in their storytelling and invention, they will still need to use images for personal expression and to make their own interpretations of their experience. How they may do this is discussed in more detail in the next section.

A detailed description of the methodologies that you can use to support children in their making of drawings for different kinds of purposes in provided in Part 1 of *Investigating and Making in Art* in this series. The development of children's image making is illustrated through examples and descriptions of their work in the following section.

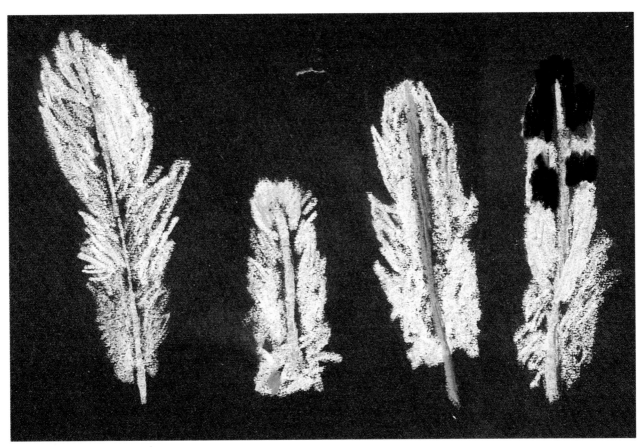

2.13 FEATHERS
Year 6
Chalks and pastels

2.12 DEAD BIRD
Year 4
Mixed media

2.14 IDENTITY CHARTS
Year 5
Pencil

EXAMPLES OF CHANGE IN CHILDREN'S DRAWINGS

The children's work that is illustrated here will provide you with some guidance as to how their changing perceptions of the world they see about them is reflected in the drawings and images that they make. They should also help you to begin to identify the level at which individual children are making their drawings and therefore what kind of support they need to progress from one stage to another.

A selection of seagulls

All of these drawings were made on the same day by children in Year 1. The teacher initiated questioning and discussion with the children about the stuffed seagull they were using as part of a class project on the sea. The children were encouraged to talk about the different shapes and colours they could see within the bird. Then they made drawings of the gull from direct observation. Some children completed the drawing in 10 minutes; others spent half an hour on the work. What is immediately evident is that the children in this one class are drawing at different levels. Some are still at that early stage of making scribbles and shapes and then 'naming' them (figures 2.15 and 2.16); others are using symbols to 'stand for' the seagull (figures 2.17 and 2.18); and some are well into making descriptive drawings (figures 2.19 and 2.20).

In Reception and Year 1, and into Year 2, it is commonplace to find children in the same class working at these different levels of perception, just as they will be using language at different levels of fluency. These differences will be most evident where the children are making drawings from observation. When you know which stage they are at, you can support them in their progress by the kind of questions you ask and the encouragement you give.

(The relationship between these stages of perception and levels of achievement is discussed in Chapter 7.)

Symbolic and descriptive portraits

The portrait drawings and paintings shown in figures 2.21 to 2.28 illustrate in more detail how children make adjustments in the way that they draw, as they seek to differentiate between each other and to identify in more detail the individual characteristics of their friends.

In the first pair (figures 2.21 and 2.22), these children in Year 1 are using simple shapes and symbols to describe their friends. Where there is appropriate questioning to focus their attention upon individual differences, they will begin to identify such characteristics as hairstyles or dress. The drawings by children in Year 2 (figures 2.23 and 2.24) illustrate how children will use combinations of symbolic and descriptive elements in the same drawing where they need to describe features such as the nose in detail. In the third pair (figures 2.25 and 2.26), the two seven-year-olds in Year 2 have made drawings that are predominantly descriptive. Although some symbolic elements remain in the drawing of the face, both children are involved in trying to explain how the clothes

2.15 and 2.16 SEAGULLS
 Year 1
 Chalks and pastels

2.17 and 2.18 SEAGULLS
 Year 1
 Chalks and pastels

2.19 and 2.20 SEAGULLS
 Year 1
 Chalks and pastels

fit on to the figure – how the cardigan fits round the shoulders and the tie emerges between the lapels of the collar. The fourth pair of drawings (figures 2.27 and 2.28), show fully developed descriptive drawings by children in Year 5 which specifically explain the appearance and characteristics of the sitter.

2.21 and 2.22
Reception and Year 1
Tempera and crayon

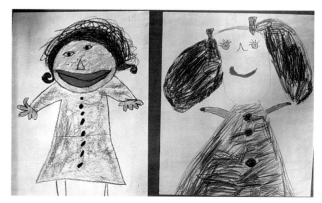

2.23 and 2.24
Years 1 and 3
Crayon and pencil

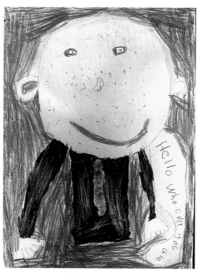

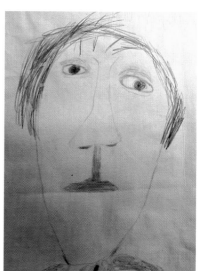

2.25 and 2.26
Year 3
Crayon and pencil

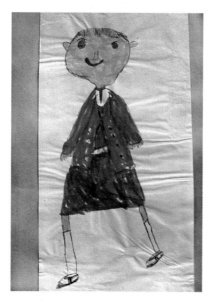

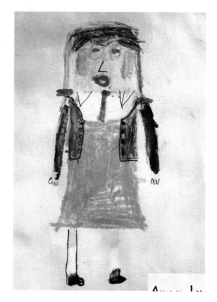

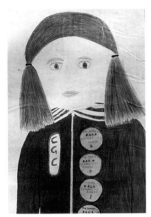

2.27 and 2.28
Years 5 and 6
*Coloured pencils, crayon
and pastel*

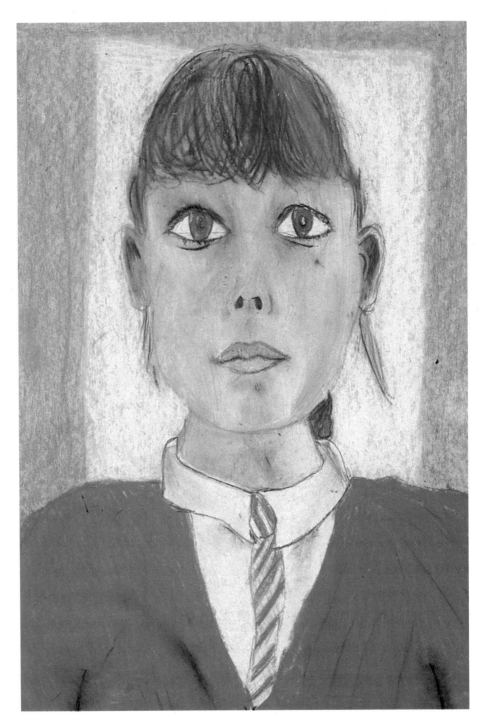

2.29 SUNFLOWER
Reception
Microliner

2.30 SUNFLOWER
Year 1
Microliner

2.31 SUNFLOWER
Year 3
Pencil

One child's sunflower

The drawings of a sunflower head (figures 2.29 to 2.31) were made by the same girl: one in her first term in the Reception class, the others in the first term of Years 1 and 3 respectively. They illustrate the way that children, in making drawings of familiar natural and made forms, progress quite naturally from using symbols or patterns to describe the form, to seeking outline shapes and internal patterns to describe its characteristics, to making a careful description of the form through recording its detail.

This series of drawings also emphasises the value of using and returning to familiar forms at different stages in the child's development to enable both you and the child to see what progress is being made.

Seeking to explain space

Figures 2.32 to 2.39 illustrate the way that children attempt to explain that things seen are three dimensional and exist in space: as when they try to describe in their drawings that houses or cars have different sides or viewpoints that can be seen at the same time, or that noses and ears actually stick out from faces. In their early drawings, children explain space very logically: the strip of blue that describes the sky is at the top of the page because the sky is up there and the bottom of the page represents the ground. The familiar symbols and shapes that represent the house are placed along the baseline of the page (figure 2.32).

They will continue to use the bottom of the page as a baseline even when their drawings of houses become more descriptive (figures 2.33 and 2.34). In Year 1, they will fit details inside the symbol for the house. By Year 4 they are able to describe and contrast two adjacent houses.

As they become more intrigued by the problems of describing houses that have both front and side views that can be seen at the same time, they will use simple (oblique) perspective systems to explain this (figure 2.38). Towards the end of **Key Stage 2** many children will begin to recognise that all the lines of the houses they see don't recede at the same angle – that the baseline of the house and the roofline are at different angles. They will begin to use elaborate systems of perspective to explain, for example, how the porch projects over the door (figure 2.39).

These various examples of the way that children progress in their making of images of familiar things should help to show how you might support them in their natural desire to seek more complex descriptions of their experience of the world in their paintings and drawings. In order to help children make that transition from representing their experience symbolically, to describing it, to investigating and analysing it, you will need to set them increasingly challenging tasks to match their developing perceptions.

Some of those methodologies that will support children in this progress are discussed in detail in Chapters 4 and 5.

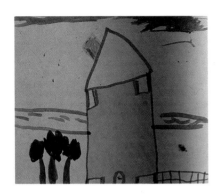 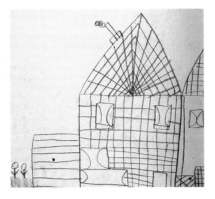 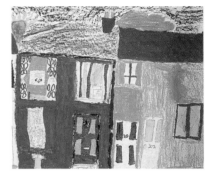

2.32 A HOUSE
Reception
Tempera
The common symbol or 'schema'
for a house

2.33 HOUSES
Year 1
Pencil

2.34 HOUSES
Year 4
Crayons

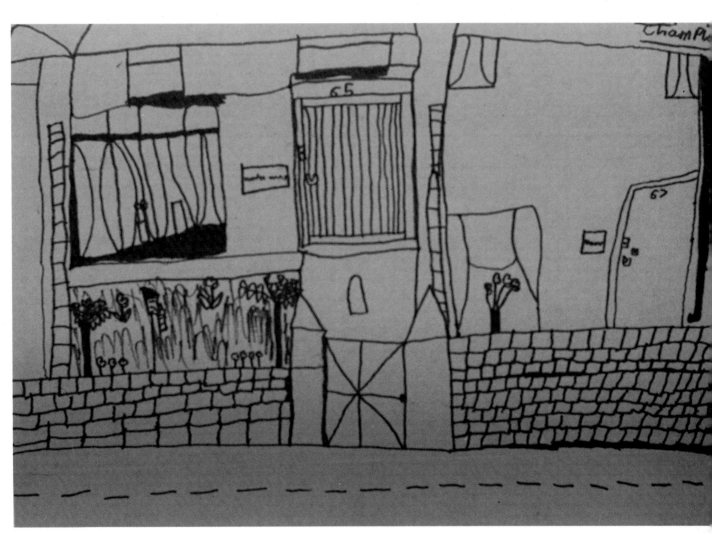

2.35 HOUSES
Year 5
Biro

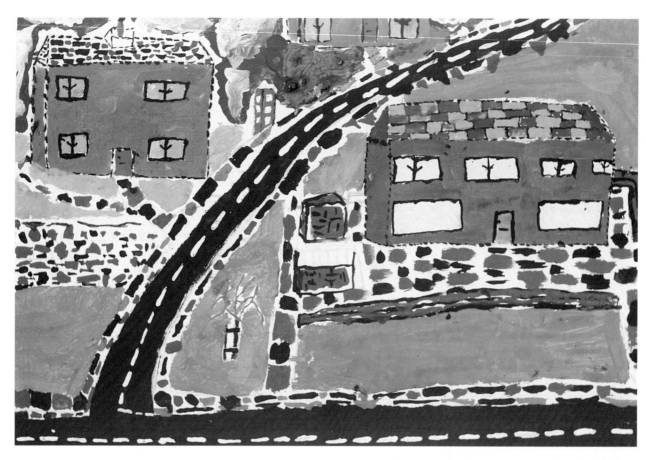

2.36 and 2.37 HOUSES
Years 4 and 5
Felt pen and pencil

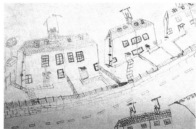

2.38 HOUSES
Year 5
Pencil

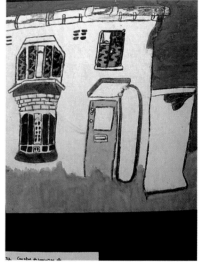

2.39 HOUSE
Year 6
Tempera and felt pen

MEMORY AND IMAGINATION

Children's ability to recall their experience has a considerable bearing upon the way in which they make their images. When they begin to draw, their first images are made almost entirely from recall. They will observe and refer to their experiences, but the drawing is made with their attention entirely upon the image as it grows upon the page. In the drawings of bicycles (figures 2.40 and 2.41), children in a Reception class looked at and talked about the bicycle; but once the drawing was under way, they were confident in their ability to make the image without further reference to its appearance. They are able to do this for those reasons already discussed in this chapter about children's ability to find symbols and shapes to correspond to those things they want to describe or comment upon, and because at this stage they are not concerned about differences between the images they make and their appearance in the real world.

This freedom they have to recount their stories and experiences symbolically allows them to draw upon things remembered flexibly and spontaneously in their first two years in the primary school. Because of this, children of five and six years of age are confident and able to make much more complex images than they are later in their school life.

Figures 2.42 and 2.43 are paintings and drawings by children in Year 1. They illustrate how freely young children will attempt to describe such complex experiences as being battered by a great storm. Their use of symbols allows them to draw directly upon their memories of such events and occasions.

2.40 BICYCLES
Reception
Pencil

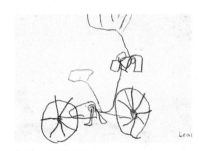

2.41 BICYCLES
Reception
Pencil

2.43 THE GREAT STORM
Year 1
Pencil and crayon

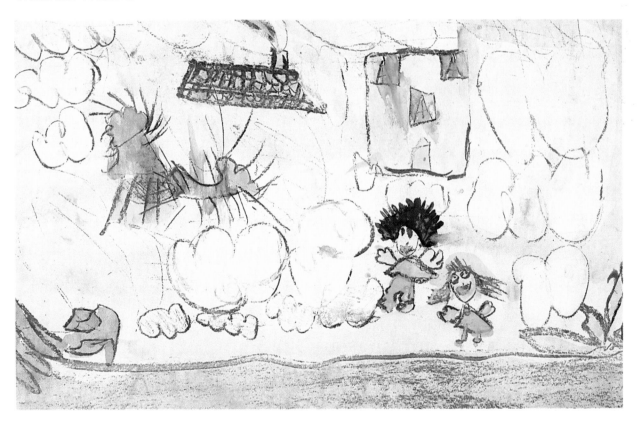

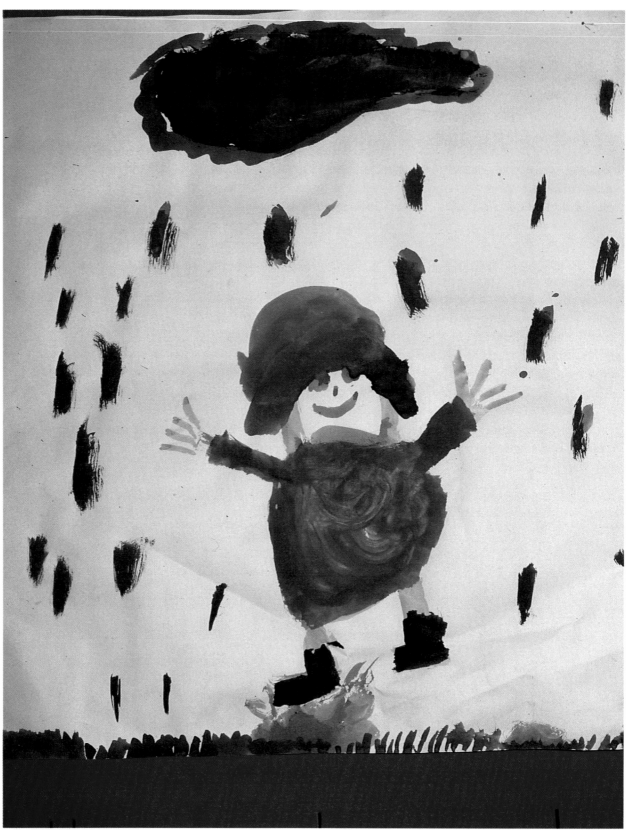

2.42 THUNDER CLOUD
Year 1
Tempera

As they progress through the school and become much more self-conscious about how images they make are received by others and how they correspond to observed appearances, their ability to portray their experiences from memory declines as dramatically as their ability to describe their experience from observation improves. This can be easily observed when we make comparisons between the drawings that children make of familiar things from both recall and observation at different stages of their schooling. In Year 1, there is little difference between the drawings that children make from both memory and observation of familiar natural and made forms. By Year 3, however, a quite considerable gap appears between the child's ability to draw from observation and from recall. The drawings of robins by children in Year 3 (figures 2.44 to 2.47) illustrate how much more confidently a seven-year-old will record a familiar bird when asked to work from a real specimen rather than from memory. By the time they reach Years 5 and 6, and for most children, there is a gulf between their ability to draw upon real and direct experience and their ability to recall past experience in their drawings.

This transition from confidence to uncertainty about drawing upon recall has significance for the way in which we ask children to make images in response to different kinds of experience. You can take a class of five-year-olds to the beach for the day, or engage in any similar experience, and the next day or later in the week they will quite happily recall that experience in their drawings (figure 2.48). Children in Year 5 would find such a task incredibly daunting because they no longer have recourse to that language of visual symbols that will allow such response.

2.44 ROBINS DRAWN FROM MEMORY
Year 3
Tempera and collage

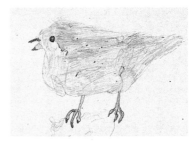

2.45 ROBINS DRAWN FROM OBSERVATION
Year 3
Crayon and pencil

2.46 ROBINS DRAWN FROM MEMORY
Year 3
Crayon and pencil

2.47 ROBINS DRAWN FROM OBSERVATION
Year 3
Crayon and pencil

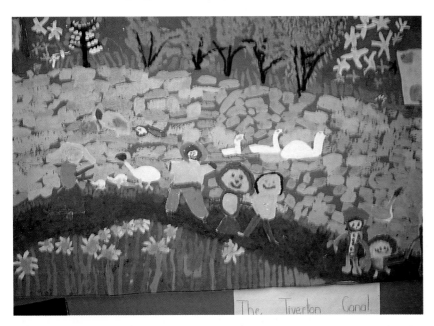

2.48 A WALK BY TIVERTON CANAL
Year 1
Tempera and collage

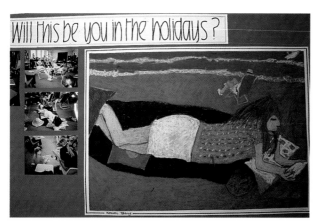

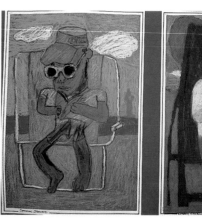

2.51 RECLINING OF THE BEACH
Years 5 and 6
Tempera

2.52 DECKCHAIR SLEEPERS
Years 5 and 6
Tempera

2.50 STUDY OF PEOPLE IN DECKCHAIRS
Years 5 and 6
Pencil

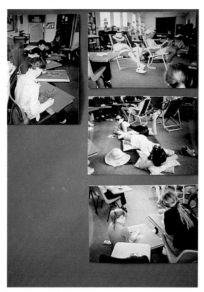

2.49 PHOTOGRAPHS OF CHILDREN RECREATING BEACH SCENES IN THE CLASSROOM

You only have to consider how difficult you would find it to recall a favourite holiday memory in a drawing to realise the dilemma that children face when you present them with tasks that are beyond them. If you want children in Years 5 and 6 to remember or speculate about their holidays at the seaside in their drawings and paintings, you would need to find ways to reinforce their recall of such occasions through recreating for them that experience in the classroom (figures 2.49 to 2.52).

Because children's powers of visual recall diminish as they progress through the school, you will need to ensure that you provide increasing opportunities for them to draw and make notes from direct observation of things they experience and visits they make as part of their programme of learning. When they visit a farm or factory or museum, or work from the local environment, they will need to make drawings and collect visual information during the visit which they can use to support their drawing, painting and modelling in the classroom. It is for this reason that the National Curriculum proposals recommend that children should keep a sketchbook in **Key Stage 2** .

Children's ability to work 'imaginatively' is also clearly influenced by this apparent decline in their ability to recall visually. In *Art from Ages 5 to 14* the part that imagination plays in children's work in Art and Design is described as follows:

> 'Imagination may be seen as a capacity to explore and experiment with memory, make new combinations of mental images and envisage an end-product which may then be realised.'

and 'When they (children) are "making it up", they are said to be working from imagination. This approach to imaginative work can encompass paintings based on vividly remembered personal experiences . . .'

Children in Reception and in Year 1 are much more likely to be able to make images based upon 'vividly remembered personal experiences'

than those working in **Key Stage 2**. This is why there will be an apparent decline in **Key Stage 2** in children's ability to work imaginatively in those schools where there is an undue reliance upon setting children tasks based upon 'remembered' occasions and events. As children move through school it becomes increasingly important to reinforce their visual memory and therefore their imaginative powers by setting them tasks which are based more upon immediate and direct experiences. There are also a number of ways in which you can both reinforce and extend children's abilities to respond imaginatively and expressively to different kinds of subject matter and experience. As in the example illustrated above, it may be necessary to re-invest their memory of spending days on the beach by recreating that experience for them in the classroom.

Similarly, following a visit to Dartmoor children's memory of the landscape might be reinforced by their seeking equivalents to the landscape in those rocks and stones they collected during their day on the moor (figures 2.53 to 2.55).

Children's expectations of the possibilities present in making a painting or drawing or model of things remembered or seen can be extended through reference to the different ways that other artists have responded to similar themes. Such methods are discussed in detail in *Knowledge and Understanding in Art* in this series.

It is important to remember that children cannot 'imagine' or 'invent' in a vacuum. All inventing or imagining is a re-ordering of experience. If you present children with a rich range of visual experiences they are better equipped to be imaginative. Children will also work more imaginatively and expressively when you place familiar tasks within an expressive context for them. It is one thing to be asked to make an observed drawing of yourself in a mirror: quite another to be asked to speculate through a drawing what you might look like in 20 years' time or what you would like to look like: different again to be asked to draw what is going on inside your own head. Children will make images and artefacts for many different purposes and in a wide variety of contexts. How they work and in what context will be influenced by the way that you frame the task of making for them. This framing is discussed in detail in Chapter 4.

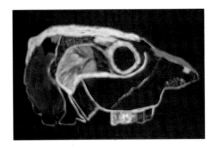

2.53 SKULL
Year 5
Chalk and crayon
A study of a skull collected on day trip to Dartmoor.

2.54 FINDING THE LANDSCAPE IN THE SKULL
Year 5
Biro

2.55 DARTMOOR LANDSCAPE
Year 5
Watercolour

3 Attainment Targets and Programmes of Study for Art in Key Stages 1 and 2

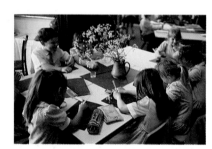

3.1 CHILDREN MAKING PLANT STUDIES FROM OBSERVATION
Year 2

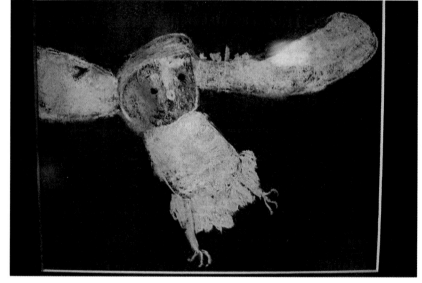

3.2 OWL
Year 1
Coloured chalk on black paper
Study from specimen on loan from
Museum Service.

THE STRUCTURE OF THE ATTAINMENT TARGETS

The Attainment Targets for Art in the National Curriculum have been determined by the aims and objectives for its teaching which were discussed in some detail in Chapter 1. The form that they take has also been influenced by a concern to reinforce the quality of the Art in our schools by giving equal attention to all the other skills and competencies that are integral to the act of making art.

In order to make art, children need to be taught how to use a variety of materials and processes and how to control the formal elements of the visual language of art: how to use colour, how to handle line and tone, how to explore surfaces and structures, etcetera. The visual language of art has to be taught as systematically as any other language.

The practical business of making art, however, cannot be separated from those other aspects which will help children to grasp and understand the purpose of their making. Children's making in Art is significantly influenced by the nature and quality of the research and investigation that takes place in support of their making. All art may be described as visual response to a variety of experience. Children are able to make more sense of their experience when they are encouraged to explore and investigate the natural and made world through observation, through talk, by making drawings and through collecting information and resources. These investigative activities strengthen their powers of observation and perception, add to their knowledge of the visual world and inform their making.

Similarly, children's making in Art is enriched through their knowledge about the work of other artists, craftworkers and designers in much the

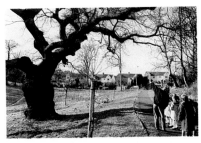

3.3 CHILDREN OBSERVING THE OAK TREE IN THE SCHOOL GROUNDS
Year 2

3.4 DRAWING THE OAK TREE FROM OBSERVATION
Year 2
Pencil

3.5 USING THE SCHOOL ENVIRONMENT
Year 2
Ink and wash
Study made from observation.

3.6 and 3.7 PLAYGROUND GAMES
Year 4
Crayons and pencil
Drawings from recall.

3.8 TEN-MINUTE STUDIES OF LOCAL CHURCH
Year 5
Pencil and biro

same way that their ability to use written and spoken language is extended through familiarity with the work of other storytellers and poets. They will learn much about the use of colour through studying how other artists have used colour, as well as through observing and making the colours they see in their environment. In giving children access to a range of work by artists working at different times and in other cultures, you can help them begin to understand the different contexts within which art is made and for what rich variety of purpose. In relating their own work to that of others, children come to have a better understanding of the meaning and purpose of their making and of the significant part that art has played in the history and development of many different civilisations and cultures.

The scope and purpose of the two Attainment Targets for Art are described as follows:

Attainment Target 1: Investigating and Making
The development of visual perception and the skills associated with investigating and making in art, craft and design.

Attainment Target 2: Knowledge and Understanding
The development of visual literacy and knowledge and understanding of art, craft and design including the history of art, our diverse artistic heritage and a variety of other artistic traditions, together with the ability to make practical connections between this and pupil's own work.

3.9 DETAILED STUDY OF CHURCH
Year 5
Pencil

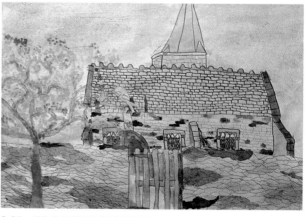

3.10 PAINTING OF CHURCH
Year 5
Watercolour, ink and wash

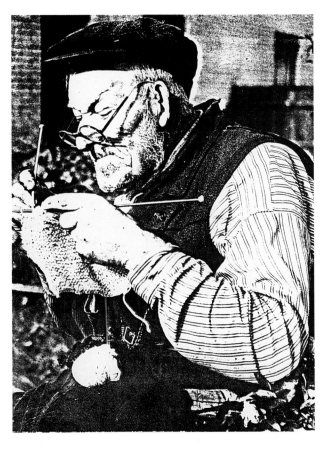

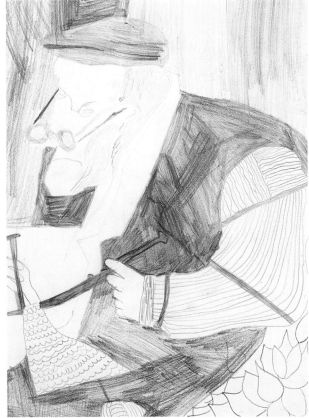

3.11 OLD MAN KNITTING
Photograph

3.12 OLD MAN KNITTING
Year 5
Pencil
Study from photograph

THE RELATIONSHIP BETWEEN THE ATTAINMENT TARGETS

The relationship between the Attainment Targets and their inter-dependence should be evident through these descriptions. They are essentially holistic in that investigating, making, knowing and under-standing are different aspects of the process of MAKING art. They are inter-linked and dependent upon each other. Effective making is dependent upon both real investigation and proper understanding.

This overlap between the two Attainment Targets is clearly expressed in the Programmes of Study which emphasise this inter-dependence between investigating, making, understanding and knowing about art.

The holistic nature of the Attainment Targets may be recognised when you consider almost any familiar activity in Art and Design and the way that its content will overlap the target boundaries. When six-year-olds are making studies of plant forms as part of a Science topic they are immediately addressing both aspects of Attainment Target 1 in that they are investigating the appearance of the plant forms and giving them form through the use of materials and processes. When making a drawing of the plant is preceded by or followed by discussion about drawings of

3.13 and 3.14 LANDSCAPES
Year 5
Photographs

Photographs used as a reference
material in conjunction with
observed drawings.

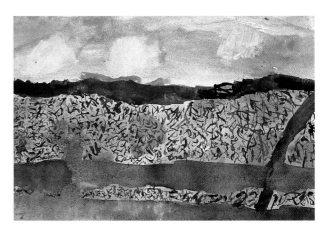

3.15 and 3.16 LANDSCAPES
Year 5
Ink and watercolours

plants made by other artists then Attainment Target 2 is also brought
into play.

Although there will occasionally be independent work within Attainment Target 2, and where the work of artists may be observed and discussed for its own sake, it will be more common for such discussion to be related to the children's own making. Only within such narrow activities as mark making and colour mixing is it likely that AT1 activities will take place in isolation and even here they are essentially preparation for giving form to things observed or remembered.

It is also very evident that children's work in Art and Design may be rooted within any one aspect of the two Attainment Targets. That familiar task of making a mask may begin within AT2 in studying the way that masks have been made in other cultures, it might be rooted in AT1 in exploring the different ways that paper and card can be cut and folded

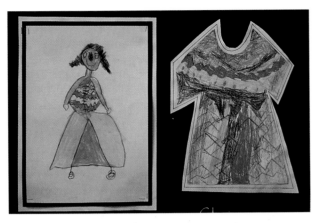

**3.17 DESIGN FOR A COSTUME
DOLL**
Year 2
Crayon and felt pen

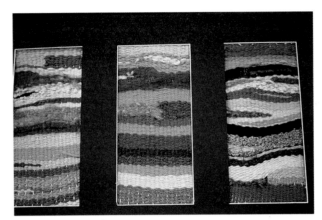

3.18 WOVEN LANDSCAPES
Year 5
Weaving
Studies of colour and pattern in
the local environment.

to cover the face; or through investigating the appearance of children wearing different kinds of disguises.

It will obviously become more easy for you to identify the Attainment Targets and how they relate to your own teaching as you become more familiar with the Programmes of Study that have been designed to help you and the children in your class match them in your work in Art and Design. The Statements of Attainment that describe what children should achieve at different levels within these Attainment Targets are discussed in detail in Chapter 6 which is about assessment.

In the National Curriculum in Art, the Programmes of Study are closely related to the Attainment Targets and this, in itself, should make it easier for you to plan those art and design projects that you will undertake to put the new art curriculum into practice.

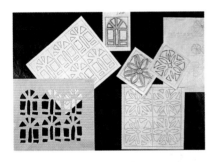

3.19 WINDOW PATTERNS
Year 4
Pencil and biro
Studies of patterns in local
windows in preparation for making
a screen print.

THE PROGRAMMES OF STUDY

The Programmes of Study describe that which children should experience and be taught in order to progress in their work from one Key Stage to another and through the Levels of Attainment. They are intended to be a framework for your work in Art and Design with children and one that you should be able to use flexibly to support existing good practice.

The Attainment Targets and their accompanying Programmes of Study are each set out in strands or components. Initially, you will find it useful to check these strands against the existing curriculum for Art in your school. This will help you to make a fairly quick comparison between the content of your own art curriculum and the balance of components that make up the National Curriculum in Art.

3.20 WINDOW PATTERN
Year 4
Screen print

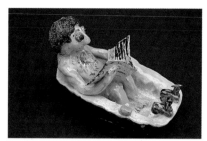

3.21 ME IN THE BATH
Year 5
Ceramic

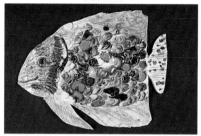

3.22 FISH RELIEF
Year 5
Ceramic

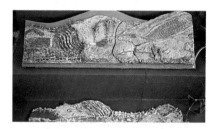

**3.23 to 3.25 NORTH DEVON
LANDSCAPE**
Year 5
Ceramic
Children worked collaboratively to
make ceramic panels based upon
drawings and studies of field
patterns and enclosures.

AT1: Investigating and Making

A Represent in visual form and communicate ideas through what they observe, remember and imagine.

B Use a range of visual resources and references to collect information and develop ideas for their work.

C Work practically and imaginatively with a range of materials and processes and understand and use the visual elements of art and design.

D Review and modify their work in the light of progress and intention.

AT2: Knowledge and Understanding

A Recognise different kinds of work in art and design and the different purposes for which it is made.

B Recognise work in art and design made in different times and cultures, know about its historical context and why artist's work is influenced by the time and place in which they live and work.

C Make connections between their own work and that of other artists, and use other artists methods and systems imaginatively in support of their own work.

The Programmes of Study for the National Curriculum in Art as described in the Final Orders are set out below. The key components in each Attainment Target are used as the basis for End of Key Stage Statements. The Programmes of Study are tabulated to show how they relate to the End of Key Stage Statements, and so that you can see the progression from **Key Stage 1** to **Key Stage 2**. Throughout this chapter, examples of children's work illustrates some of the Programmes of Study to help you to identify how they correspond in practice to your own school. Figures 3.1 to 3.27 relate to AT1, and figures 3.28 to 3.40 relate to AT2.

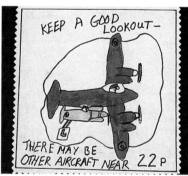

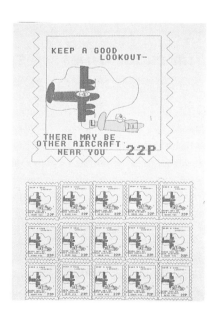

3.26 and 3.27 STAMP DESIGNS
Year 6
*Drawings in felt pens and computer-
aided designs*
Designs for stamps to
commemorate achievements in
flight made as part of a class topic
on the development of flight.

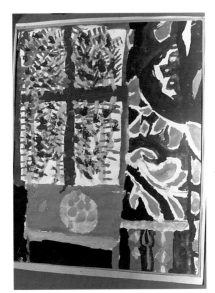

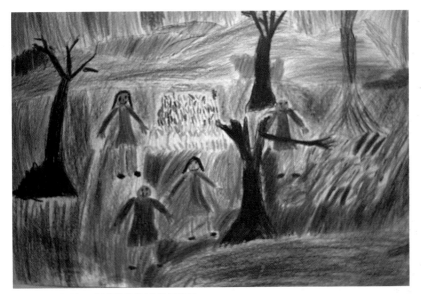

3.28 THE EGYPTIAN CURTAIN
Year 2
Tempera
A 6-year-old makes his own
version of a painting by Henri
Matisse.

3.29 and 3.30 AUTUMN LEAVES
Year 3
Crayons and pastels
Paintings of bonfires made by
children after observing and talking
about the painting 'Autumn Leaves'
by John Everett Millais (1829–96).

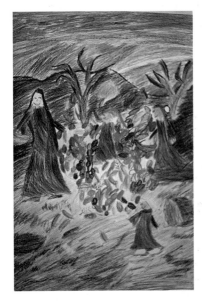

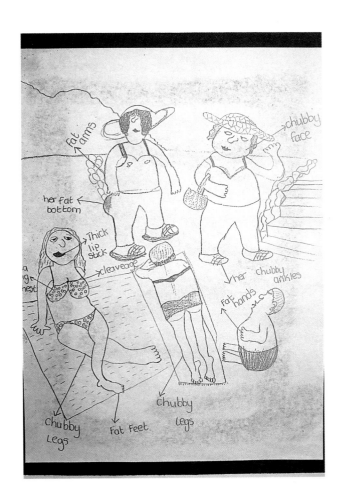

**3.31 and 3.32 STUDYING A
PAINTING**
Year 5
Pencil and biro
Analysing a painting by Beryl
Cook.

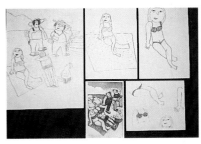

Attainment Target 1: *INVESTIGATING AND MAKING*

The development of visual perception and the skills associated with investigating and making in art, craft and design.

Key Stage 1		Key Stage 2	
End of Key Stage Statement	*Programme of Study*	*End of Key Stage Statement*	*Programme of Study*
By the end of key stage 1, pupils should be able to:	Pupils should:	By the end of key stage 2, pupils should be able to:	Pupils should:
A represent in visual form what they observe, remember and imagine.	i record observations from direct experience of the natural and made environments. ii respond to memory and the imagination	**A** communicate ideas and feelings in visual form based on what they observe, remember and imagine.	i select and record images and ideas from firsthand observation. ii respond to memory and imagination using a range of media.
B select from a range of items they have collected and use them as a basis for their work.	iii collect and sort images, objects and source materials.		iii use a sketch-book to record observations and ideas.
C work practically and imaginatively with a variety of materials and methods exploring the elements of art.	iv explore a range of materials, tools and techniques. v explore how images can be made through using line and tone, working with a variety of tools and materials. vi explore colour-mixing from primary colours. vii explore and recreate· pattern and texture in natural and made forms. viii explore the use of shape, form and space in making images and artefacts. ix make three-dimensional work for a variety of purposes.	**B** develop an idea or theme for their work, drawing on visual and other sources and discuss their methods. **C** experiment with and apply their knowledge of the elements of art, choosing appropriate media.	iv experiment with ideas suggested by different source materials and explain how they have used them to develop their work. v apply their knowledge and experience of different materials, tools and techniques, using them experimentally and expressively. vi experiment with different qualities of line and tone in making images. vii apply the principles of colour mixing in making various kinds of images. viii experiment with pattern and texture in designing and making images and artefacts. ix experiment with ways of representing shape, form and space. x plan and make three-dimensional structures using various materials and for a variety of purposes.
D implement simple changes in their work in the light of progress made.	x review their work and modify it as they see the need for change. xi talk about their work and how they have made it.	**D** modify their work in the light of its development and their original intentions.	xi adapt or modify their work in order to realise their ideas and explain and justify the changes they have made. xii use a developing specialist vocabulary to describe their work and what it means.

Attainment Target 2: *KNOWLEDGE AND UNDERSTANDING*

The development of visual literacy and knowledge and understanding of art, craft and design including the history of art, our diverse artistic heritage and a variety of other artistic traditions, together with the ability to make practical connections between this and pupils' own work.

Key Stage 1		Key Stage 2	
End of Key Stage Statement	*Programme of Study*	*End of Key Stage Statement*	*Programme of Study*
By the end of key stage 1, pupils should be able to:	Pupils should:	By the end of key stage 2, pupils should be able to:	Pupils should:
A recognise different kinds of art.	i identify examples of art in school and the environment.	**A** identify different kinds of art and their purposes.	i compare the different purposes of familiar visual forms and discuss their findings with their teachers and peers.
	ii identify different kinds of art, present and past.		ii understand and use subject-specific terms such as landscape, still-life, mural.
B identify some of the ways in which art has changed, distinguishing between work in the past and present.	iii look at and talk about examples of work of well-known artists from a variety of periods and cultures.	**B** begin to identify the characteristics of art in a variety of genres from different periods, cultures and traditions, showing some knowledge of the related historical background.	iii look at and discuss art from early, Renaissance and later periods in order to start to understand the way in which art has developed and the contribution of influential artists or groups of artists to that development.
C begin to make connections between their own work and that of other artists.	iv represent in their own work their understanding of the theme or mood of a work of art.		iv identify and compare some of the methods and materials that artists use.
		C make imaginative use in their own work of a developing knowledge of the work of other artists.	v experiment with some of the methods and approaches used by other artists, and use these imaginatively to inform their own work.

3.33 MISS TYLER
Year 5
Tempera

3.34 MISS MATHEWS
Year 5
Tempera

THE FLEXIBLE USE OF THE PROGRAMMES OF STUDY

In order to become familiar with the Programmes of Study and how they relate to your own teaching, you will find it useful to review the work that your class has done in response to a recent topic. Identify which Programmes of Study have been addressed through this work. In doing this you will soon discover that the Programmes of Study may be used quite flexibly and that the same combinations of Programmes of Study can be used to generate different kinds of art and design activities. For example, a teacher working with a group of children in Year 2 might select the following **Key Stage 1** Programmes of Study and use them as the framework for the design-based and expressive-based projects described below.

AT1

i) Record observations from direct experience of the natural and made environments.

iii) collect and sort images, objects and source material.

iv) Explore a range of materials, tools and techniques.

v) Explore how images can be made through using line and tone, working with a variety of tools and materials.

vi) Explore colour mixing from primary colours.

vii) Explore and recreate patterns and texture in natural and made forms.

AT2

i) Identify examples of art in school and the environment.

ii) Identify kinds of art, present and past.

iv) Represent in their own work their understanding of the theme or mood of a work of art.

Expressive-based project

● Collect family photographs and pictures of special occasions, e.g. weddings, birthdays, outings, parties.
● Compare these with scenes of celebration in paintings by different artists, and with illustrations in contemporary storybooks.
● Make studies from these resources of colours and patterns in clothes that are worn for special occasions.
● Make paintings of each other wearing party clothes.
● Make studies from paintings, storybooks, recipe books and magazines of the different kinds of food that are served at special occasions.
● Work collectively to make group paintings and collages of 'A feast for a special occasion'; for example, a wedding or harvest supper, a birthday or class party.

Design-based project

- Collect photographs of local buildings — houses, shops, churches, public buildings etc. and photographs to show how the local community has changed over the years.
- Compare your community with communities represented in paintings and illustrations from different times and cultures.
- Make pattern rubbings, colour studies and diagrams to show how building materials are used in your locality.
- Select a 'timeline' of buildings from your city, town or village. Work in pairs or small groups to make studies of the chosen buildings to describe how they are made and with what materials.
- Work individually and collectively to make a series of paper and card prints of those buildings chosen to represent the changing face of your community.
- Assemble the prints to make a local buildings book.

Although both these projects are based upon the same group of Programmes of Study in **Key Stage 1** , they would involve the children in different kinds of art and design activities and in making different kinds of responses to the resources used. In much the same way, children will make different kinds of drawings in response to the same visual resources or starting points and using the same materials, depending upon the context within which the drawings are made.

A successful art and design curriculum is as dependent upon children being required to work in a variety of context and for different purposes as it is upon their being taught to use a range of materials and processes.

3.35 INDIAN ARTEFACTS
Part of a collection of artefacts used in association with a visit to the school by the weaver, Bobby Cox, who had just returned from a journey to India.

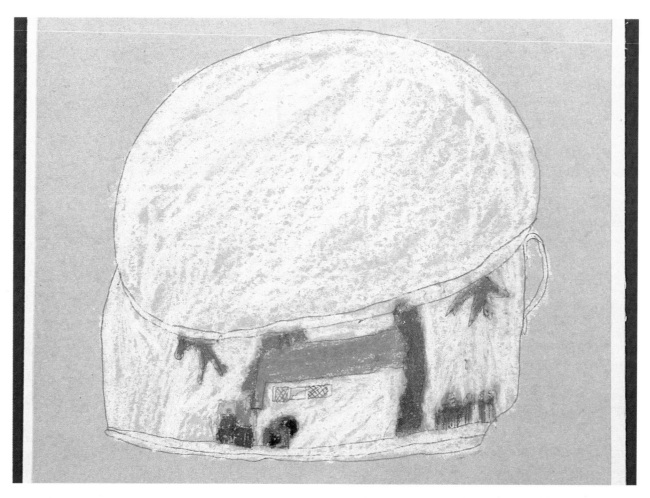

3.36 and 3.37 STUDIES OF VICTORIAN ARTEFACTS
Year 2
Pencil and crayon
Studies made in association with a class History topic: '100 Years Ago'.

3.38 SCULPTURES OF BIRDS BY JENNIE HAYLE
Year 3
Ceramic

**3.39 and 3.40 DRAWINGS OF
SCULPTURES BY JENNIE
HAYLE**
Year 3
Pencil

4 Placing work in Art and Design in context for children

4.1 TEDDY BEAR
Year 1
Tempera on coloured ground

4.2 JAWBONE
Year 2
Chalk and crayon on black ground

THE IMPORTANCE OF CONTEXT

The development of a National Curriculum in Art with agreed Attainment Targets and Programmes of Study to match the declared aims and objectives for the subject goes some way towards establishing a coherent context for its teaching.

Attainment Targets

The structure of the Attainment Targets will ensure that the making of art by children is no longer an isolated activity dominated by techniques and processes. Investigation and enquiry will provide purpose for their making in requiring children to seek out and research for their ideas in the natural and made environment. The emphasis upon critical and contextual studies will help children to begin to understand the connections between their own making of images and artefacts and the way that artists and designers have contributed to the appearance and shape of our own culture and that of other civilisations.

Programmes of Study

The Programmes of Study address a range and balance of investigative and making activities that will encourage children to make art in different kinds of contexts and for different purposes in the same way as they use both spoken and written language variously in their everyday lives.

In making images, children are responding to different kinds of experience. What kind of images they will make and for what kind of purpose will be significantly influenced by the way in which you frame that experience for them by setting the task of making the image or artefact within a particular context. Children may draw and paint themselves, their friends, families, favourite possessions, objects and events in their environment for all kinds of reasons. They will make images as they will use language for increasingly complex purposes as they progress through their primary school.

It is an important part of your armoury as a teacher to understand how you can encourage children to use the familiar visual experience of their everyday world to progress from making simple to complex visual statements and to recognise how their image making can serve a variety of purposes. That variety of purpose may be evident when you consider how many different ways and for what purpose children may make drawings of such familiar subject matter as the house. What kind of drawings they will make of houses will be determined by:

 i) how the task is framed for them
 ii) what questions are asked of them
 iii) what pool of imagery and resources they have access to.

4.3 PEBBLE PATTERN
Year 3
Oil pastels and crayons on grey ground

FRAMING THE TASK

● If children are asked to draw a house – any house – and without much supporting discussion, they will usually make a stereotype for the house: a rectangle with a central door and a window in each corner (see figure 2.32), a triangle for the roof and perhaps a chimney. Those children with more mechanical dexterity may draw a more 'skilful' stereotype and may be confident enough to add details like door knockers, curtains at the window or a garden fence.

● If the same group of children are asked to draw their own house, following on from some detailed talk and question and answer about the differences between the houses they live in, then they will make more considered drawings. Their drawings are now based upon some kind of experience – their knowledge of their own house, reinforced through discussion with the teacher which helps them to recall important aspects of their own house.

● If you take the same group of children to a nearby terrace of houses and through looking, talking, making notes, writing down words, making diagrams etc. encourage them to identify how neighbouring houses are different to each other, they will be able to make drawings that differentiate between the houses. This is because you will have focused their attentions upon comparison through the shared experience of looking, describing and comparing.

● Show children a doll's house with its front removed so that they can see the house in section and all its rooms at the same time. Then, after some discussion about this kind of view, ask them to make a drawing or diagram of their own house to show how it is lived in and used. The purpose, quality and appearance of the drawing will change again.

● In contrast, you can present children with good photographs of the façades of houses. Using graph paper, rulers and sharp pencils, teach them how to construct the façade on the basis of units of measurement. If the front door occupies three square units on top of each other, how many squares do the windows occupy, how many squares are there between the windows etc.?

● If children are asked to invent the buildings that will house the mythical or funny creatures that feature in a recent story, then again the drawings that follow will take on a different purpose and quality.

These different contexts within which children might record the appearance and character of houses all have different and useful purposes. They involve them in such different activities as recalling, describing, comparing, analysing, speculating and imagining.

In planning for your work with children within a particular project or across the year, it is important to consider that range and balance of context within which the children can work. In teaching them to make images for different purposes and in different kinds of contexts you are helping them to become visually more literate and confident in the use of visual language.

DESCRIBING AND RECORDING

Perhaps the most familiar context within which children will work in **Key Stage I** and **Key Stage 2** is where they are seeking to describe or represent something they have experienced. This activity will be undertaken for its own sake and for the pleasure of recording the appearance of things that the children enjoy. It also has important cross-curricular implications in that learning in many other subjects is dependent upon the children's ability to record their experience of such things as familiar artefacts from the past and evidence of change in the environment.

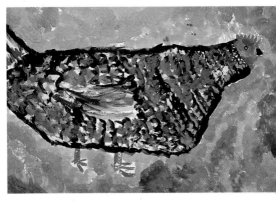

4.4 CHICKEN
Year 4
Tempera

The two key factors in developing the children's skills of recording are in the supportive use of the language of description and in the selection of materials and tools that will help the children to observe what is before them.

Language

The importance of good supporting talk – describing, questioning, discussing – cannot be over-emphasised. It is through talk, as much as through looking, that children come to observe more perceptively. You can focus their looking in a number of ways:

● through carefully structured questioning about what they are observing,
● through encouraging discussion and comparison within the class,
● through supportive vocabulary work.

If a class of children in Year 3 working in pairs, begin their recording of familiar things, by listing those words that describe what they are observing, this will immediately sharpen their perception of what is before them.

Matching materials to visual resources

Children's ability to see and then record what they saw is strengthened where there is a careful match between the quality of what is being observed and the materials being used to record the observations. They will find, for example, that it is much easier to make studies of white or coloured feathers working with white or coloured chalks and crayons on a dark ground than when presented with white paper and a pencil. When making their paintings of the first daffodils of Spring, five-year-olds would find it confusing to be asked to work with the standard range of ready mixed colours. They need to be given the limited range of colour that relates to the colours in the plant they are painting.

You can help children to undertake describing and recording tasks with confidence where you support them by using descriptive language and appropriate resources in harness. (The teaching of observed drawing and painting is dealt with in detail in *Investigating and Making in Art*, Part I 'Investigating'.)

4.5 CHILDREN USING VIEWFINDERS TO SELECT A SECTION TO STUDY FROM THE COMPLEX PATTERN OF A SNAKESKIN

COMPARING AND ANALYSING

Once children have become familiar with the routine of making 'careful looking' drawings and have become confident in making their observations of everyday natural and made forms, then they ready to begin to use their looking and drawing skills more selectively. It is a logical step to move from working within a descriptive context to beginning to make comparisons between things and to analyse their appearance and structure. By the time they move into **Key Stage 2**, most children are well into that stage where they are curious and inquisitive about all things and 'why' and 'how' they appear and work the way that they do.

Working within a comparative context can start early in the school. Children will quite naturally make comparisons between each other, will make drawings to explain why one teddy bear is different to another, to compare one sweet with another, to differentiate between things they like and things they don't like. They can be encouraged to make these comparisons by setting them the task of making drawings and paintings to distinguish between similar forms – their shoe and their friend's shoe, two similar feathers, contrasting teapots etc.

They will work more selectively and analytically where you are able to find ways to focus their attention upon particular aspects of the natural and made world of their environment. Simple examples of children working analytically are where they are asked to make rubbings of different patterns and surfaces in their environment, where they make a colour chart of all the colours they can see in an autumn leaf, where they record all the different shapes and structures of the satellite dishes in their locality. In working analytically they are collecting, selecting and sifting visual information. This kind of work is an important and supportive element in their work in Science and Technology.

Key strategies to support analytical work are in the use of focusing devices and in the careful choice of those materials and processes that will help children to make that selection within the form they are studying.

Using viewfinders to select detail

When children are making studies of complex forms (figures 4.5 to 4.7), they will need viewfinders that will help them to select and isolate a section they can deal with. When working from small scale or very detailed forms, they will need magnifying glasses to help them select and see that detail (figure 4.8).

Choice of material is crucial because it is obvious that what information children can extract from the forms they are studying is determined by the materials they are working with. When they are making studies from a leaf working with a biro or a microliner, they will extract different information to when they are working with crayons or pastels: one media allows them to focus upon and record its pattern, the other to explain and analyse its combinations of colour.

It is important for children to be able to investigate the natural and

4.6 PYTHON SKIN PATTERNS
Year 5
Pencil and crayon

4.7 SNAKESKIN PATTERNS
Year 5
Charcoal

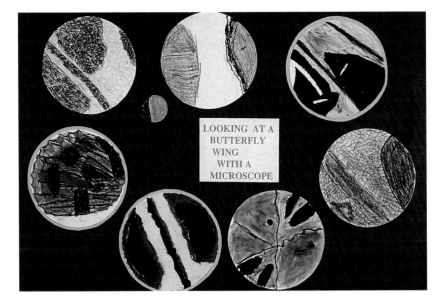

4.8 BUTTERFLY WINGS
Year 5
Coloured pencils and pastels
Studies of butterfly wings made using magnifying glasses and microscopes to select and focus upon detailed pattern.

**4.9 DRAWINGS AND STUDIES
FOR PATTERN DESIGNS**
Year 5
Various media

**4.10 STUDIES FOR STAINED-
GLASS WINDOW DESIGNS**
Year 6
Various media

made world through making comparative and analytical drawings. These skills are essential support to their work in Science and Technology where such investigation enables them to collect and sort evidence and to consider alternative solutions and possibilities.

Seeking information to support designing

All design-based work in Art and Design in schools is dependent upon the children's ability to select visual information from a variety of sources and to consider what combinations of colours, surfaces or shapes might be used effectively within the design of such artefacts as a weaving, a postage stamp, a ceramic panel or an item of personal adornment.

(The teaching of investigative drawing is dealt with in detail in *Investigating and Making in Art*, Part I 'Investigating'.)

**4.11 DESIGNING A LOGO FOR
MUSICAL INSTRUMENT
MANUFACTURER –
PRELIMINARY STUDIES**
Pencil

4.12 SECOND STAGE
Felt pens

4.13 DESIGN PROPOSALS
Inks

COMMUNICATING

In their early years, children's drawing, painting and modelling will take place predominantly within the context of storytelling. This has already been discussed in detail in Chapter 2. In Reception and in Years 1 and 2, children are happy and confident in their use of a range of symbols to tell stories about their early experience in the world.

Children will also use drawings to convey different kinds of information about the world they live in, as in a diagram or pictorial map in which they may describe their journey from home to school or use a series of drawings to explain a journey made by a favourite fictional character such as Postman Pat (figure 4.14). When you challenge children to use their developing drawing skills to tell a particular story or to describe a sequence of events, you are placing their image making in the context of communicating information. Such information can be factual, descriptive – or speculative. Using images to convey different kinds of information is an important beginning to developing children's visual literacy. This has a high profile in the aims and objectives of the National Curriculum in Art.

There is a whole host of visual communication forms which are part of children's everyday lives and which can be used as source material for this kind of work. These include comics, television commercials, signs and symbols, pop-up books, games, posters, etc. It is a genuine challenge to children to involve them in problems of communicating information without using words or using images in association with words.

4.14 POSTMAN PAT'S JOURNEY
Reception
Crayons and felt pens

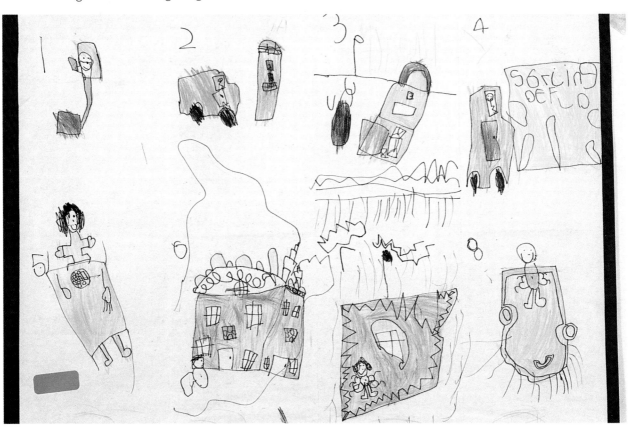

4.15 CHILD MAKING A SERIES OF DRAWINGS TO TELL A STORY
Year 2

4.16 MAGIC SPELL
Year 4
Crayons and felt pens

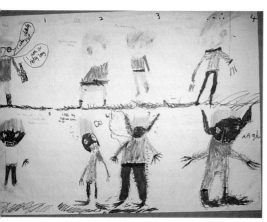

4.17 MAGIC SPELL
Year 4
Crayons and felt pens

Comic strip drawings

All children are familiar with and can use the convention of conveying information through a series of images, as in the comic book (figure 4.15). Such familiarity with this convention can be used constructively when you ask children to make a series of drawings to explain how they undertake such daily tasks as tying their shoelaces, making a cup of tea, and getting up in the morning. Such conventions can also be used to encourage children to speculate about or imagine what would happen if . . .? Figures 4.16 and 4.17 illustrate how children in Year 4 responded to the challenge of explaining through a series of drawings how they would change in appearance if they met a witch who cast a magic spell upon them. They were asked to make at least eight drawings to show exactly how the change took place as they were turned into something else.

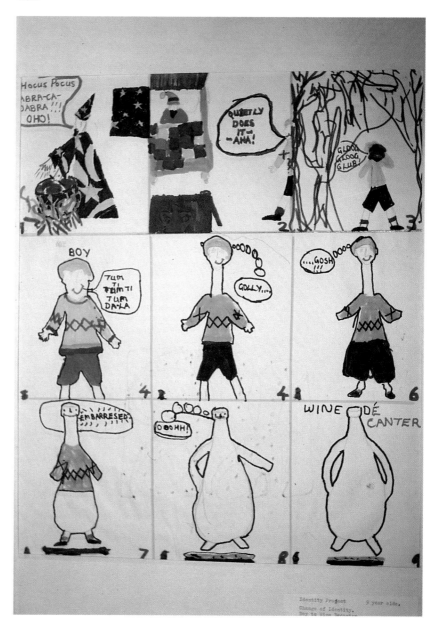

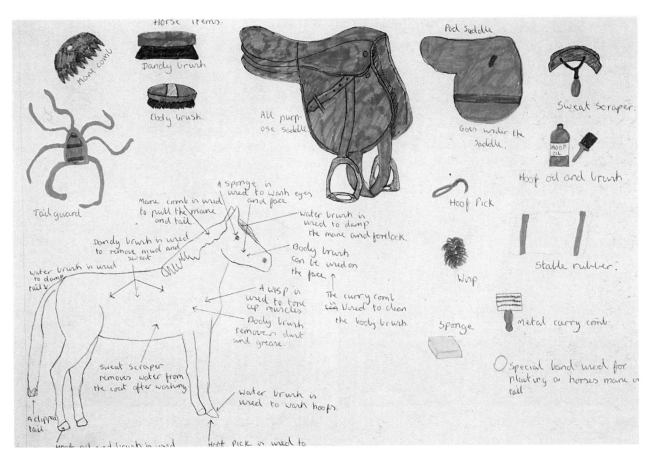

4.18 HOW TO GROOM A HORSE
Year 6
Coloured pencil and felt pen

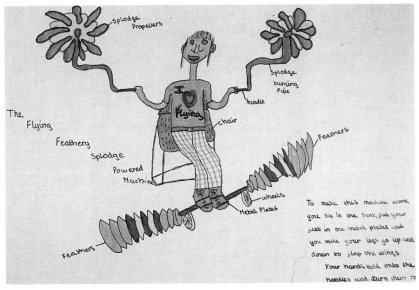

4.19 HOW TO USE A FLYING MACHINE
Year 6
Crayon and felt pen

Information drawings

Children can also be encouraged to use a combination of drawing and writing for the more functional purpose of explaining how things work or how they might be made to work (see figures 4.18 and 4.19). These skills are very supportive to their work in Technology, where they need to be able to explain or speculate about the appearance and structure of familiar or imagined forms.

**4.20 STUDIES FROM THE
SCULPTURE**
Year 6
Pen and wash

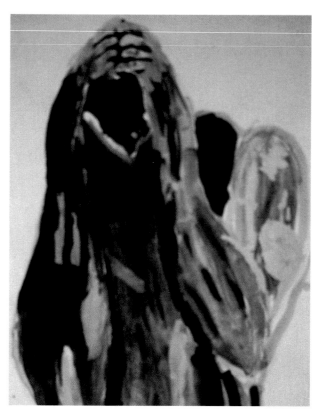

**4.21 STUDIES FROM THE
SCULPTURE**
Year 6
Pen and wash

**4.22 CHILDREN IN THE CLASS
POSED TO EXPRESS
'UNHAPPINESS'**
Year 6
Ink and charcoal

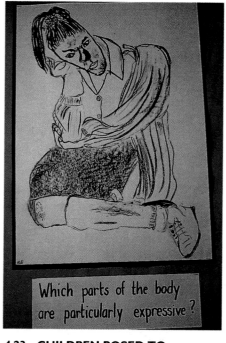

**4.23 CHILDREN POSED TO
EXPRESS 'UNHAPPINESS'**
Year 6
Ink and charcoal

IMAGINING AND EXPRESSING

The challenges of enabling children to work within an expressive context have been discussed in some detail in Chapter 2 and, in particular, the need to ensure that as children move through your school they are presented with expressive tasks that are based upon direct experiences.

> 'Children cannot imagine or invent in a vacuum. All inventing or imagining is a re-ordering of experience. If you present children with a rich range of visual experiences they are more likely to be better equipped to be imaginative.'

Expressive drawings

Children are more likely to work expressively where they are presented with expressive tasks and resources. If you want to explore with children the expressive notion of the contrast between being sad and happy then an immediate resource is the hand mirror which will enable them to compare their own sad and happy expressions. This could be further reinforced through using photographs or reproductions of works of art in which people are represented in contrasting moods. Figures 4.20 to 4.23 illustrate the drawings made by children in Year 6 who studied photographs of Auguste Rodin's sculpture 'The Burghers of Calais'. They made studies from these and then made drawings of children posing in similar attitudes of sadness and despair to the figures in the sculpture.

Similarly, a child in Year 3 will make an expressive painting to illustrate the poem 'The Highwayman' when the figure of the highwayman with his lantern is reconstructed for them in the classroom (figure 4.24). A child in Year 6 is more likely to make a dramatic drawing of a seascape when that drawing is made in immediate response to a walk along a cliff path on a windy day (figure 4.25).

Responding to experience

Like artists, children respond effectively to expressive experiences. Their paintings of circus clowns from distant memory of their last visit to a circus will be very different in quality to their paintings of clowns in response to someone dressing up and 'clowning' for them in their class-room. When they are themselves seriously engaged in making a dance and interacting through movement with a partner in the class, then their drawings in response to that encounter may reflect something of its expressive quality (see figures 4.26 and 4.27).

4.24 THE HIGHWAYMAN
Year 1
Tempera

4.25 CLIFF FACE
Year 6
Pencil, charcoal and chalk

4.26 TWO CHILDREN MAKING A 'SNAKE DANCE'
Year 5

4.27 DRAWING MADE TO SHOW WHAT IT FELT LIKE IN THE DANCE
Year 5

You can help children to understand the expressive possibilities within their own work by using the work of other artists to show them how different artists have responded to the themes they are working upon. When they make comparisons between the works of other artists they will begin to recognise that in Art there are different ways of interpreting and making expressive responses to familiar subject matter. Just as their reading of the work of other writers and poets opens up for them the possibilities of language, so their study of other artists' work will help them understand that there are different ways of expressing ideas and meanings in making images.

(The use of the work of artists and designers is discussed in detail in *Knowledge and Understanding in Art* and drawing to communicate information and ideas is dealt with in *Investigating and Making in Art*, Part I 'Investigating'.)

USING CONTEXT

In the teaching of language, it is common practice for teachers to help children to understand and use language in different contexts. In any one term, you are likely to require the children in your class to use spoken and written language descriptively, transactionally and expressively. If children are to become 'visually literate' then it is just as important that they are similarly provided with opportunities to make images and artefacts in different contexts and for different purposes.

You can reinforce for children their understanding of making for different purposes by occasionally taking them through a number of different tasks in response to a familiar resource or starting point. For example, starting with a shoe that they are wearing on that day, you could set them the following tasks in this sequence:

1 Keeping their feet firmly under the table, draw their shoe from memory.
2 Compare their shoe with the drawing from recall. Make a carefully observed drawing of the shoe in pencil, focusing upon detail and pattern.
3 Use a viewfinder to find the most interesting part of the shoe and make a study of its surface and colour, working with charcoal, chalk and oil pastels.
4 Working in pairs, take one shoe and work out how it is made. How many parts has it? What shapes are they? How are they assembled? Make a working drawing to explain how the shoe is manufactured.
5 Use the working drawing to reconstruct the shoe in a suitable material, e.g. paper or clay.
6 Make speculative drawings about how the shoe might be re-designed for a special occasion such as a party.

In working through these tasks, children would be engaged in making work in different kinds of context even though the subject matter or content remains unchanged. They are progressively working from recall and through describing and comparing appearances; they are analysing the structure of the shoes and reconstructing their form; they are making drawings to inform others about how they are made and speculating about how they might be re-designed.

Thinking about the context in which you are asking the children to work can provide both a structure and a balance for the pattern of your own teaching of Art and Design. In the example given above, the different tasks are supportive to each other. The earlier tasks in which the children investigate and learn about the appearance of their shoes are supportive to the analytical, designing and speculative tasks that follow.

BALANCE AND STRUCTURE

When you are planning art and design projects, whether free standing or in association with and linked to work in other subjects, it can be very helpful to use the different contexts in which Art can be made as a framework for your planning. It is a comparatively simple matter to identify the different kinds of context in which you have asked children to work over a period of time and to ensure that you are keeping them in reasonable balance.

Context

In **Key Stage 1**, because of the way that their image making develops, children are more likely to be working within the context of storytelling, describing and comparing. In **Key Stage 2**, analysing, informing and speculating are likely to have a higher profile.

It is particularly helpful to use different context as a planning matrix when you are designing cross-curricular work to ensure that within the larger theme, which may well be focused upon concerns within the Sciences or Humanities, you are maintaining both progression and a sensible balance in your work in Art and Design. Otherwise, it is all too easy for the pattern of work in Art to be distorted by the general theme and for the work in that term to be unduly dominated by, for example, descriptive drawing from observation.

The two examples below show how one teacher has planned work in Art and Design within two general cross-curricular themes – 'Buildings' for Years 3 and 4 and 'The river bank' for Years 5 and 6. The work is set out so as to show both the balance of processes and materials used and the context within which each activity takes place.

BUILDINGS – a project for Years 3 and 4

ACTIVITIES	DRAWING	PAINTING
Descriptive work	Drawing in the local community and on trip to Hoe/Barbican. Looking down from Civic Centre and Smeatons Tower. Drawing of own house from memory and observation.	Looking at work of L S Lowry. 'Smoky city' paintings based on these.
Analytical work	Searching for details using a viewfinder. Making rubbings of patterns in different buildings.	Looking from school across city seeking patterns and shapes. Paintings from this using very thick paint.
Communicative/expressive work	Annotated drawings from trips – story map. Looking at line drawings by Paul Klee – invented cities based on these using black fibre pens.	Illustrative work from the story *Fattypuffs and Thinifers*.

STUDIES OF THE RIVER BANK – a project for Years 5 and 6

ACTIVITIES	DRAWING	PAINTING
Description	In the field – drawing (pencil and colour work) observing environmental as well as detailed elements; careful drawings of collected items to support other work.	Look carefully at ways other artists have painted flowers and plants/wildfowl etc. Make water paintings of case specimens following this 'looking' (e.g. fish).
Analysis	Explore the way in which different leaf shapes/colours can be worked together. Investigate the way plants intertwine – how we can show a complicated group of plants, some behind others.	Begin to keyhole elements of field sketches – experiment with enlarging and reducing – play with photocopied images (tangle of roots). Colour and pattern of river pebbles under water.
Communication	Design a wardrobe of clothes for one of the characters in *Wind in the Willows* which reflects their animal characteristics. Design a boat for gnomes or a 'gnome' alphabet.	
Expression	Using a description of gnomes, disguise a friend and draw them as a gnome.	Using a limited ink palette, develop the preliminary drawings of the most frightening tree shape in the Wild Wood.

PRINTING/COLLAGE

Houses – printed using only a roller and printing inks. Thinking about shapes behind others. Drawings of own houses used to print a street using polyblocks.

Repeated pattern work using chimney or window shapes. Class collage of rubbings and collected textures as display.

Three-dimensional work: making 'City cubes' boxes based on drawings from Paul Klee stimulus and referring to pictures made by Petr Markey, toymaker.

TEXTILES

Using frayed fabrics, overlaid scrim etc. create a riverside environment that would make people want to touch it.

Use a combination of fabric and thread techniques to interpret a scene from the Wild Wood.

Design a fabric 'habitat' for the invented creature to live in.

CERAMICS/3D

Using analytical drawings of leaves and plants to create a plaque of entwined foliage.

Make a 3D ceramic map of uncharted country based on stories read.

From descriptions in the book and other personal ideas, make a model of Toad Hall.

After looking at freshwater insects/ invertebrates, design and make an unusual creature.

You will see that planning and setting out work in this way helps to ensure there is progression from activity to task, that the children receive a good balance of work in different art and design processes and that the important issue of using different kinds of context is properly addressed.

Curriculum leaders for Art and Design will be providing valuable support to their colleagues in schools where they can introduce similar planning devices to support the delivery of the National Curriculum in Art in their schools.

Flight project

Figures 4.28 to 4.43 illustrate the work from one class of children in Year 6 who were engaged for one term with that familiar Science and Technology based theme of 'Flight'. They show how such a theme can be enriched through providing for the children a range of art and design tasks which have value and purpose in their own right. These address working in different contexts and also extend the children's understanding of the history and science of flight.

4.28 SEED HEADS
Year 6
Coloured chalks on black ground

4.29 SEED HEADS
Year 6
Coloured chalks on black ground

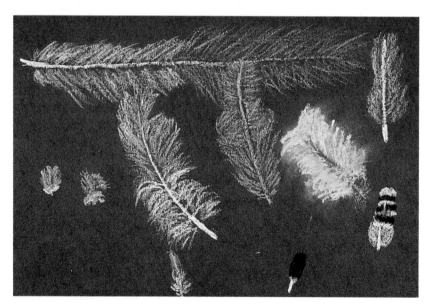

**4.30 COMPARATIVE STUDIES
OF FEATHERS**
Year 6
Chalks and pastels on black ground

**4.31 COMPARATIVE STUDIES
OF FEATHERS**
Year 6
Chalks and pastels on black ground

4.32 and 4.33 AERIAL VIEWS
 Year 6
 Crayons and felt pens
 Speculative drawings of the bird's
 eye view from above their home
 or school.

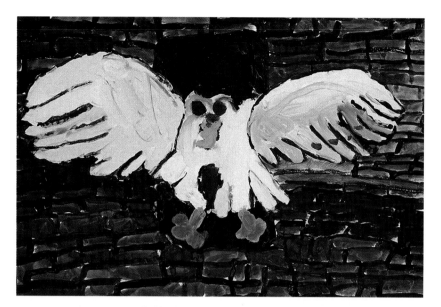

4.34 and 4.35 MYTHICAL AND EXOTIC BIRDS OF FLIGHT
Tempera and oil pastels

4.36 to 4.39 FLYING MACHINES
Biro, microliner and felt pens
Designs for flying machines based initially upon drawings by Leornardo da Vinci.

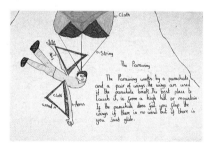

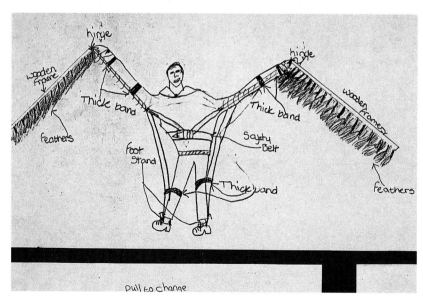

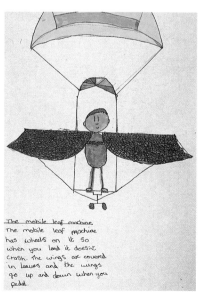

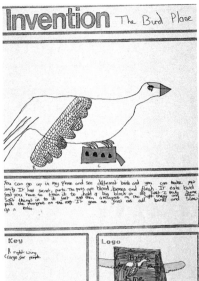

4.40 INVENTION SHEET
Pencil and felt pens
Speculative design for a bird plane.

4.43 THE BUMBLE BEE
Computer-aided illustrated poem.

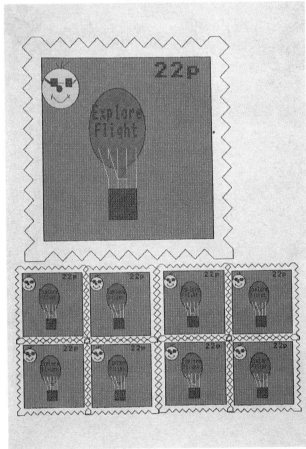

4.41 STAMP DESIGNS
Computer-aided designs for a set
of stamps on theme of flight.

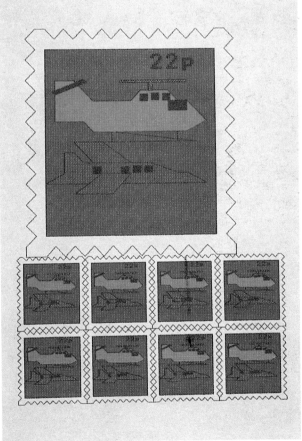

4.42 MORE STAMP DESIGNS
Computer-aided designs for a set
of stamps on theme of flight.

5 Art and Design across the curriculum

CROSS-CURRICULAR ISSUES

Art and Design has its own subject disciplines which have to be taught if children are to obtain any efficiency in their making of images and artefacts. The Programmes of Study for Art in the National Curriculum establish what children should be taught in **Key Stage 1** and **Key Stage 2** .

In many primary schools, Art and Design is taught well and in its own right and its teaching is effectively harnessed to aspects of the teaching of other subjects. Now that children have to be taught all the core and foundation subjects in **Key Stage 1** and **Key Stage 2** , it is essential to the efficient management of their learning that the working relationship between subjects is fully understood in order to deliver the National Curriculum effectively.

One of the central principles to the establishment of the National Curriculum was a desire to reduce 'curriculum clutter' and to ensure a better management of children's learning as they progress from teacher to teacher and from school to school. In primary schools and where the foundation subjects are taught primarily through cross-curricular themes or topics, it is important to understand how Art and Design can be used both to enrich and extend the teaching of other subjects. It is also important to understand how they, in their turn, can contribute to children's learning in Art. This interweaving of subjects is well managed in many schools. In good practice, it is evident that the teaching of Art and Design benefits where there is positive and constructive overlap with other subjects. It is also evident in day-to-day practice that the quality of art teaching in primary schools suffers where the subject is taught in isolation and where, in cross-curricular work, Art and Design is used as a decorative afterthought to illustrate what has already been taught and learnt.

Some of this curriculum overlap is evident, as in the close match between art and language in children's early storytelling and in that useful marriage between the teaching of Science and Art and Design that delivers much of the Programmes of Study for Technology in **Key Stage 1** and **Key Stage 2** .

Some overlap of content is evident in the Programmes of Study for other subjects. The Attainment Targets for Science, for example, require that children in **Key Stage 1** should be able to discriminate between colours, match them and describe familiar and unfamiliar objects in terms of their shape, colour and texture.

There is significant overlap of content between Attainment Target 2 in Art and Design and Attainment Target 3 in History, through which children will learn about other times and cultures by studying the images and artefacts their people made.

Although some curriculum linking can be established through identifying common content with other subjects, the most useful relationships will be found through seeking the common purposes that subjects share. These were explored in the previous chapter. They were illustrated with examples of planning to show how identifying the context for your work

can support your design of teaching projects and ensure some element of balance and progression in the development of the work.

The working relationship that Art and Design shares with other subjects are explored as follows:

> Art and Language
> Art, Science and Technology
> Art and the Humanities
> The Arts

ART AND LANGUAGE

The interaction between Art and Language has already been discussed in Chapter 2 in considering the relationship between communicating visually and orally in the early years:

> 'When a child's vocabulary is limited to a few hundred words, the making of a drawing may enable them to make more complex statements than words will allow.'

It was also discussed in Chapter 4 through exploring the important link between visual perception and the use of language in making observational and comparative drawings:

> 'It is through talk as much as through looking that children come to observe more perceptively.'

There is no doubt that the rich use of language is significantly supportive to observation and that good talk about what is being observed will improve the quality of the drawn response. Children will make better drawings from observation when you focus their 'looking' through carefully structured questioning and discussion about what is being observed. It is similarly self-evident that the quality of the children's written response will also be heightened through this good marriage between observation and talk.

The observation of familiar natural and made forms may be used to generate different kinds of writing. The following extract is from a description of a cow's skull made by a child in Year 6 as part of a Science project which resulted from careful observation of the appearance and function of the skull:

> 'The skull is hard and has lots of tiny pieces packed together very tightly. In his nose there are tiny bits of the skull. There is one tooth that is thick and wobbly and a bit rotten. The skull is pretty heavy and if you get a magnifying glass and put it to the skull and look around, it looks like a cave. It is a good sight inside. It is a bit grubby. On our skull you can see where the neck bone was and where the brain was stored'

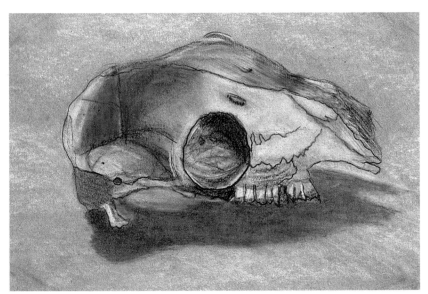

5.1 SHEEP'S SKULL
Year 6
Pencil, chalk and charcoal on grey ground

The children in this class were asked to make drawings of the cow's skull following upon the written response. Figure 5.1 is a drawing of a sheep's skull made by a child in Year 6. The class observed the skulls, talked about their appearance and then drew them. After they had drawn the skulls objectively, the children were asked to write poems to describe their feelings about them, in association with reading other poems and discussion about the meaning of skulls as symbols. One child wrote:

5.2 and 5.3 SEA CREATURES
Year 6
Computer-aided drawings and poems

> The skull that looks but doesn't
> The mysterious hollow head
> The living but now dead
> The darkened cave inside
> Horribly uneasy feelings creep
> back to your fingers.
> As you touch the dead bone
> The lumpy, yellow white bone
> The living contents banished
> Nowhere to be seen
> The skull that's cracked
> Been sewn together
> The skull that looks but doesn't.

In making images, children are communicating their observations, ideas and feelings in response to different kinds of experience. In writing a story or making a poem, children will be using language for such similar purposes. There are many opportunities here for linking and complementary work in Art and English.

The interplay between observing familiar forms and responding to them through both making drawings and using forms of language to describe them is illustrated in figures 5.2 and 5.3. Children in Year 6 made computer-aided drawings and used word-processing to make illustrated poems about barnacles, prawns, limpets, sea anemome and starfish as part of a class topic on 'The seashore'.

5.4 STORY WALL
Years 2 and 3
Emulsion paints on playground wall
Illustrations for stories about life in the sea made in response to a 'storyteller' in residence.

5.5 THE BALLOON SELLER
Year 4
Watercolour
Using photographs of fairgrounds to support children's illustrations about a visit to the fair.

5.6 THE HOUSES OF PARLIAMENT
Year 4
Tempera
Using a painting of London by Claude Monet (1840–1926) to support children's illustration of the story 'Lucy and the Wolf'.

5.7 THE BETRAYAL
Year 4
Tempera
Using the painting 'The Betrayal' by Ugdino di Nerio to support children's illustration of the Easter theme.

Much of children's listening to or making of stories will generate the need to make associated images that will call upon their ability to recall events or to speculate about the appearance of things. As discussed in Chapter 2, younger children will not find this difficult since they can use their symbolic systems of image making to handle quite complex subject matter (see figure 5.4). Where older children in **Key Stage 2** are reading and making stories that they need or want to illustrate, then it becomes important to find ways to place that illustration in such context that they can handle it effectively. For example, children reading Roald Dahl's *James and the Giant Peach* could be usefully engaged in studying and drawing the mini-beasts that might infect the peaches; those studying Nina Bawden's *Carrie's War* could make studies of themselves dressed and labelled as evacuees or wearing a gas mask. There are many ways in which you can reconstruct for children events within their reading of both fiction and documentary work that will enable them to illustrate their response to that work effectively.

You may need to call upon good illustrations to the work of fiction, photographs and the work of other artists to help children see how they can make images that match the quality of both their reading and writing. This will be particularly important when there is a need to illustrate complex subject matter or environments and events that are far removed from the children's own experience.

There are some stories and poems that are so powerful in their description of events or evocation of atmosphere that they can in themselves generate exciting visual response from children. Figures 5.8 to 5.13 illustrate children's work related to the study of the poems 'Hiawatha' and 'The Rhyme of the Ancient Mariner'.

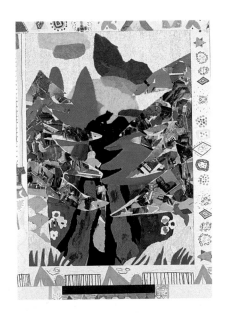

5.8 and 5.9 'HIAWATHA' VERSE WITH DECORATIVE BORDER

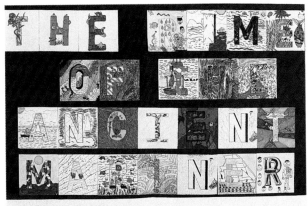

5.10 DISPLAY OF ILLUMINATED TITLE TO 'THE RHYME OF THE ANCIENT MARINER'
Year 6
Fibre tip and felt pens

5.11 ILLUMINATED LETTER 'E'
Year 6
Fibre tip and felt pens

5.12 ILLUMINATED LETTER 'T'
Year 6
Fibre tip and felt pens

5.13 ILLUMINATED LETTER 'O'
Year 6
Fibre tip and felt pens

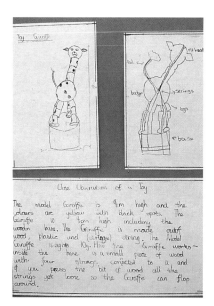

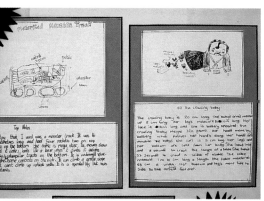

5.14 and 5.15 WORKING DRAWINGS OF TOYS
Year 5
Pencil
Drawing and writing to explain how familiar toys work.

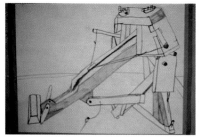

5.16 CROSSBOW
Year 5
Pencil
Working drawing of crossbow made in preparation for designing and making siege weapons for a joint History/Technology project.

ART, SCIENCE AND TECHNOLOGY

The teaching of Art and Design, Science and Technology are closely enmeshed in **Key Stage 1** and **Key Stage 2** and it has been encouraging to see how well those schools that already had in place a good working relationship between Art and Science were able to cope with the introduction of Technology to the National Curriculum. It is generally accepted that Science is concerned mainly with the development of scientific skills, attitudes and concepts. Many of these scientific skills are directly linked with Art. Observation, using all the senses and accompanied by discussion, encourages children to classify their findings and to identify similarities and differences in objects and living materials. Interpreting their information, looking for patterns in growth, life cycles or structures, suggesting relationships, making predictions and raising questions from analysing their observations are all essential skills that children should begin to acquire at an early age.

The use of drawing to develop the skills of description, comparison and analysis has already been discussed in this publication and is dealt with in considerable detail in *Investigating and Making in Art*, Part 1 'Investigating'.

Where schools have in place a well-structured programme of drawing and where children are taught how to use drawing for different purposes, then these skills will contribute significantly to their ability to make those investigations that are essential to scientific understanding. They will be able to investigate the structural properties of a wide range of made and natural forms and record effects and changes in such physical phenomena as colour, light, weather, growth, change and decay etc.

The advent of Technology in primary schools has established more common ground between Science and Art and Design by requiring that scientific enquiry and designing and making should work together in harness to address the solving of problems within a range of social contexts. The overlap between Art and Technology is evident in the structure of their respective Attainment Targets. There is significant overlap between 'Investigating' in AT1 in Art and AT1 in Technology 'Identifying needs and opportunities'. Here in both subjects children will be using research skills and drawing skills to examine existing forms and to consider how they are structured and how they might be modified (see figures 5.14 to 5.16). There is similar overlap between AT1 in Art and AT2 in Technology 'Generating a design', where again there is reliance upon children being able to use drawings to plan and speculate about how they might respond to a designing task (see figures 5.17 and 5.19).

In both subjects, there are Programmes of Study which focus upon the act of making and with the way that children will use and manipulate materials and processes in support of their making. It is important to understand some of the differences between 'making' within the context of Art and Design and making within the context of Technology.

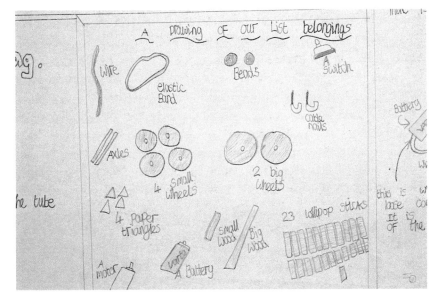

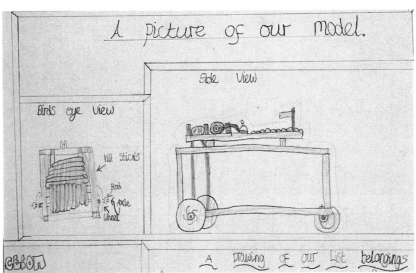

5.17 to 5.19 WORKING DRAWINGS
Year 6
Pencil and coloured pencils
Drawings to speculate about the construction of a working model and to organise its making.

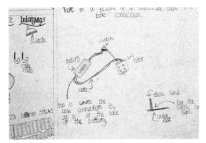

Making in Art and making in Technology

A key element within the technology curriculum is that all designing and making should take place with a social context and in response to opportunities and needs identified by the children. Children are required to design and make artefacts, environments and systems in response to identified needs within such context as the home, school, environment and leisure.

In Art and Design much of their making will be generated through a personal need to use their practical skills and knowledge to express ideas, feelings and meanings about their experience of the world. They will frequently be using similar processes to make images and artefacts within both a personal and a social context. They may use clay to make a model of a friend or favourite pet, or to construct a container to house plants in the school environment. They may use a range of processes in textiles to make images in response to things they have seen in their

environment or to make artefacts for a specific purpose (figure 5.20). They might use their skills in drawing and graphic design to construct a story board to recall an important event or to design a container or wrapper for sweets and cakes they are making for a special social event.

Figures 5.21 to 5.24 show children planning and making decorative headgear to wear for a special occasion within the school. These illustrate how the Attainment Targets for both Art and Technology are being properly addressed within one curriculum project. The children experimented with structure and patterns before testing their hats.

5.20 TIES
Year 4
Pencil, crayons and printed fabric

5.21 DESIGNING AND MAKING HATS – PLANNING
Year 5
Various media

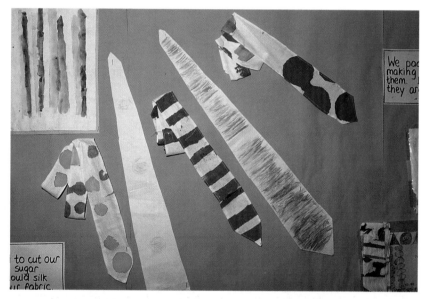

5.22 EXPERIMENTING WITH STRUCTURE
Year 5
Various media

5.23 EXPERIMENTING WITH PATTERNS
Year 5
Felt pens

5.24 TESTING
Year 5

ART AND THE HUMANITIES

The working relationships between Art and Language and Science and Technology are based upon their sharing processes such as communicating, expressing, investigating and analysing. Children's ability to describe and communicate their findings through investigation and drawing has impact upon their work in the Humanities and contributes significantly to field work in Geography and to their ability to research and document historical evidence in their own environment. The skills of observation and recording developed through work in Art are intrinsically valuable to all subjects in the curriculum.

Additionally, Art and Design and the Humanities share a number of similar concerns and concepts. These subjects have common roots in that learning about life in other cultures, in other times and places, is dependent upon the study of the work of those artists, craftworkers and designers which provides such rich evidence of life in other communities. Archeology is essentially the study of past civilisations through their buildings, images and artefacts.

Through the study of the work of artists and designers in other cultures, we can draw conclusions about the way that people used to live and what were the influences upon them. For example, the Bayeux Tapestry, the paintings of Hieronymus Bosch, Nicholas Hilliard's miniatures and prints by Katsushika Hokusai all reveal a great deal about life and times in other cultures and places.

5.25 and 5.26 THE BAYEUX TAPESTRY
Year 2
Mixed media and collage
Using the Bayeux Tapestry as source material to support a History project about the Norman invaders.

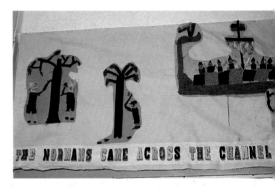

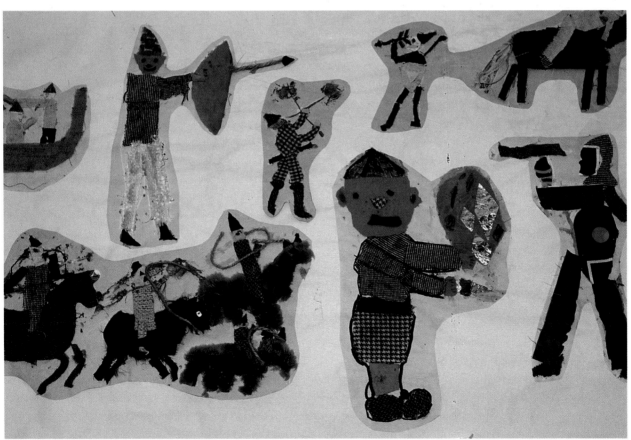

The Humanities and the Arts also share the exploration of such similar concepts as cause and effect, similarity and difference and continuity and change. The Programmes of Study for both History and Geography emphasise the value of children learning about other places and the past through direct experience, study of their local environment and through studying real evidence of the way that people live and work in other times and cultures. There is now, for example, a strong link between AT2 in Art 'Knowledge and Understanding' and AT3 in History 'The use of historical sources'. In Art, children are required to study the work of artists, craftworkers and designers working in a wide range of cultures and contexts. In History, children are expected to learn a great deal about the past through a similar study of the work of artists and designers whose work is evidence of past achievements.

This emphasis upon the examination of real environmental and historical evidence reinforces the value to their work in the Humanities of children having those observational and recording skills that already contribute to their work in the Sciences and Technologies.

There is also advantage in the fact that the National Curriculum in History now requires that children study a set pattern of times and cultures in **Key Stage 1** and **Key Stage 2**. This will enable teachers and schools to put in place those resources and reference materials relating to the work of artists, designers, craftworkers and architects that will make a good match between the requirements of the Programmes of Study for both Art and History.

In **Key Stage 1** in History, children's historical awareness will be generated through the study of myths and legends, eye-witness accounts of historical events, stories about historical events and the study of the lives of famous men and women including artists.

In **Key Stage 2**, the National Curriculum requires the study of the following cultures:

- Invaders and settlers, such as the Romans, Normans, Celts and Vikings
- The Tudors and Stuarts
- Victorian Britain
- Life in Britain post-1930
- Ancient Greece
- The Aztecs

Supplementary study units offer such opportunities as the study of the history of buildings or printing and the requirement that there should be study of non-European cultures, such as those of Egypt, Mesopotamia, Assyria, Maya and Benin.

In all this, there are rich opportunities for complementary work between Art and History. There will also be overlapping use of reference and resource materials that are equally valuable to both subjects. Figures 5.27 to 5.31 illustrate work by children in Years 5 and 6 where works of art from such contrasting sources as Greek sculpture and photographs of the London Blitz from *Picture Post* have illuminated

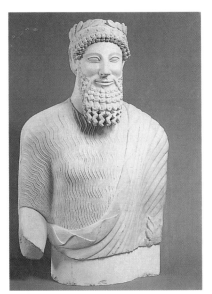

5.27 ANCIENT GREECE – GREEK SCULPTURE

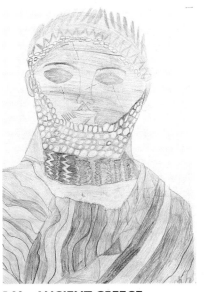

5.28 ANCIENT GREECE – STUDY OF SCULPTURE
Year 6
Pencil

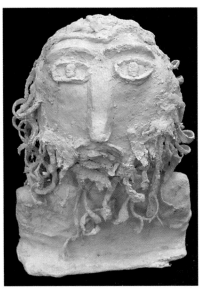

5.29 ANCIENT GREECE – RECONSTRUCTION OF SCULPTURE
Year 6
Modroc

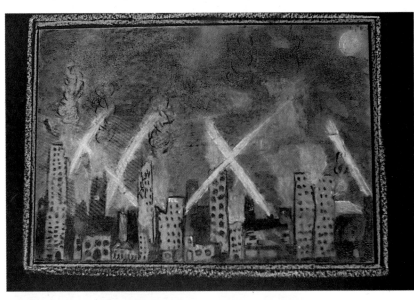

5.30 and 5.31 THE LONDON BLITZ
Year 5
Chalk and charcoal on grey ground
Studies of the blitz of London made from photographs published in *Picture Post* during the 1939–45 war.

children's understanding of the events of these times. Figures 5.32 to 5.39 illustrate the way study of the Tudors has been enriched for children in Year 5 through the use of real evidence of the costume, architecture and painting of that period in history.

5.32 THE TUDORS
Year 5
Part of costume display borrowed from local theatre company.

5.35 to 5.37 STUDIES FROM ELIZABETHAN MINIATURES
Year 5
Fibre pens and pastels

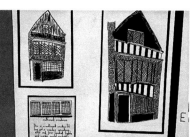

5.38 STUDY OF TUDOR MERCHANT'S HOUSE
Year 5
Pen and ink

5.33 TUDOR CLOTHES
Year 5
Teacher and children wearing Tudor clothes and acting as models for the class.

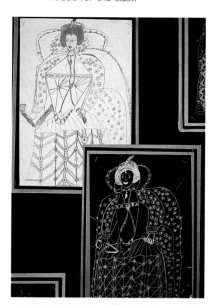

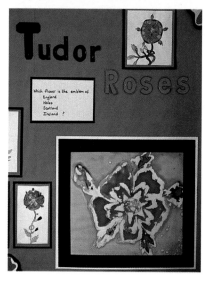

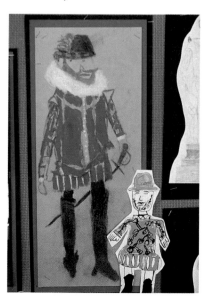

5.34 THE TUDORS
Year 5
Fibre pens and pastels
Studies from the model.

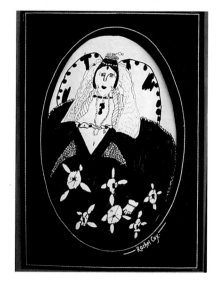

5.39 DESIGNS FOR TUDOR ROSES
Year 5
Watercolour and batik

THE ARTS

The Arts do serve common purpose with each other culturally within schools as in their communities. They are an important arena within which schools share and celebrate their work with their communities through exhibitions, performances, concerts and events. Collectively, the Arts play an important part in educating children to be conscious of their own work as artists and performers and of the relationship between their own work and the place of the Arts in the wider community of their own culture.

Within many primary and secondary schools the visual arts, music, drama and dance are taught as separate disciplines. This is often because each has its own discrete and distinct skills and processes that have to be experienced in order for children to become confident and fluent in expressing their ideas, feelings and meanings through the media of the Arts. Although the Arts do have this common purpose to communicate to others ideas and feelings through the media of images, sound, interaction and movement, the processes are very different to each other. Because of this, the Arts need to seek to work collaboratively together in schools rather than in that overlapping and holistic way that Art and Design can work with Technology.

The making of Art and Design is predominantly an individual activity and is characterised by reflection upon visual experience. Drama is essentially a group activity and is characterised by interaction in tension. Music is a combination of individual and group activities and is characterised by the reworking of existing musical forms.

Many of the skills that children acquire through working in the separate Arts disciplines are not easily transferable across the arts. Although music and dance share common skills in movement and rhythm, the skills of observation, investigation and recording that children may acquire through their work in Art do not contribute directly to their performance in Music and Drama.

In primary schools, the Arts work best together where they are linked rather than integrated and where ideas and feelings expressed in one arts form are built upon and developed in another. The writing and poetry that can be generated through response to the first snows of winter may well be further pursued through work in drawing and painting: there is a natural flow between storytelling and drama: work in sound in Music may well be used to generate interesting work in dance.

Figures 4.26 and 4.27 show two children working together to make a dance and the drawing made by one child in response to that experience. The same child wrote about that experience of making the dance:

> 'I liked all the weeks we did dance. I was excited and I let myself go like a bird sweeping everywhere. Then a snake in the grass, a fish, a bird. I didn't care. I didn't want to leave the dance because I could express my emotions. It is the only subject I can express my emotions.'

This is a nice example of the way that a child may use the separate disciplines of dancing, writing and drawing effectively and expressively.

Working across the Arts occurs most frequently in primary schools where the separate disciplines are used in harness to present to parents and friends a performance or event. Where such events are built upon an existing dramatic text, such as the 'Nativity play' or 'Joseph and his Amazing Technicoloured Dreamcoat', then the music making and work in Art and Design will tend to become service agents to the drama.

There are rich opportunities for the Arts to work on more equal footing where the performance grows out of a cross-curricular activity and children use the different arts forms to explore ideas and then bring them together in performance. Figures 5.40 to 5.45 illustrate the work made in Art and Design by children in Years 3 and 4 in association with the presentation of a dance-drama about bird life and movement. This was based upon a work of fiction and involved the children in studying the movement of different kinds of birds, writing about them, creating their own dance to the movements of birds, designing and making bird masks and costumes and composing music to accompany the dance.

5.40 and 5.41 BIRDS: COMBINED ARTS PROJECT
Years 3 and 4
Studies of birds from photographs and book illustrations.

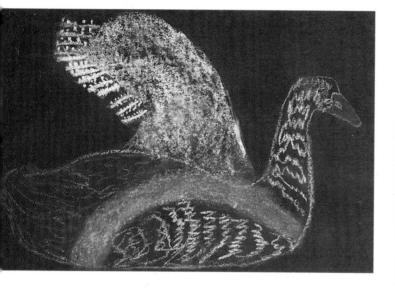

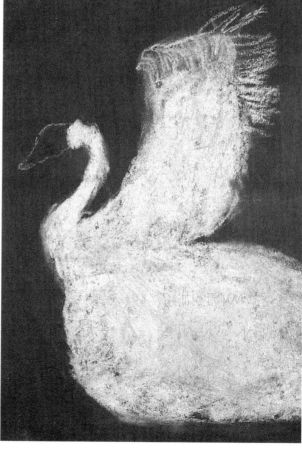

5.42 and 5.43 BIRDS – MAKING THE DANCE
Years 3 and 4
Charcoal and chalk on grey ground
Drawings based upon the experience of dancing like a bird.

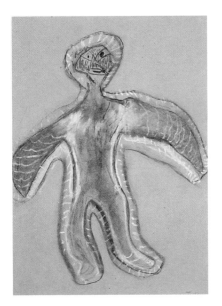
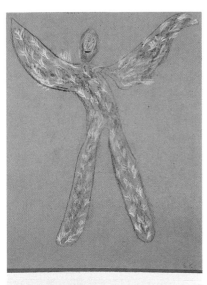

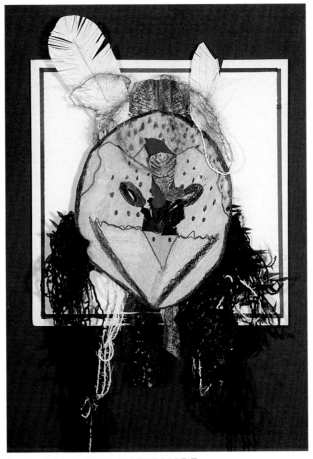
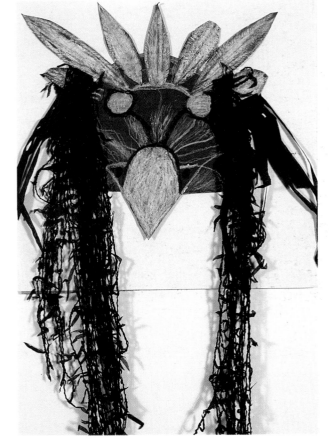

5.44 and 5.45 BIRD MASKS MADE FOR THE DANCE
Years 3 and 4
Mixed media

6 Reflection and appraisal

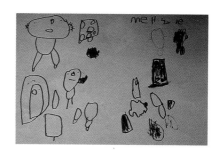
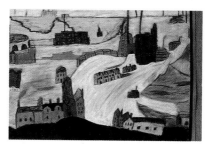

REFLECTION

The National Curriculum in Art requires that children should be encouraged to reflect upon their work and its progress and be actively engaged in its appraisal. This requirement is centred in Attainment Target 1: Investigating and Making.

> 'Pupils should be able to talk about their own work and why they have made it; make modifications to their work arising from . . . discussion.'

The Programmes of Study that support this aspect of AT1 are described as follows:

Key Stage 1	Key Stage 2
Pupils should:	**Pupils should:**
x) review their work and modify it as they see the need for change.	xi) adapt or modify their work in order to realise their ideas and explain and justify the changes they have made.
xi) talk about their work and how they have made it.	xii) use a developing specialist vocabulary to describe their work and what it means.

Opportunities for reflection are also present in AT2 'Knowledge and Understanding' in requiring that:

Key Stage 1	Key Stage 2
A Pupils should:	**A Pupils should:**
iii) look at and talk about examples of work of well-known artists from a variety of periods and cultures.	iii) look at and discuss art from early, Renaissance and later periods in order to start to understand the way in which art has developed and the contribution of influential artists or group of artists to that development.
iv) represent in their own work their understanding of the theme or mood of a work of art.	v) experiment with some of the methods and approaches used by other artists, and use these imaginatively to inform their own work.

Encouraging children to review the progress of their work is identified as being a positive part of appraisal in *Art for Ages 5 to 14*:

> 'Where there is good practice in art education, assessment is an essential element in the creative process itself. Pupils involved

in art, craft and design are constantly assessing, evaluating and making judgements about their work, as a result of which they may decide to make modifications and refinements.'

Although many primary school teachers encourage children to talk about their work in Art and to share their work with others informally and occasionally more formally, as in assemblies, the notion of structuring opportunities for children to reflect upon their work may be a comparatively new one. It is important to remember that children's reflection upon their own work and your own appraisal of their achievements is most easily managed where it grows out of dialogue between children and with the children about the task in hand.

In Art and Design education and in the training of artists and designers, there has long been in place the practice of 'negotiated assessment' where the teacher shares with the student the progress of making images and artefacts.

BEGINNING WITH TALK

Talking with children about their work is a natural extension of that 'naming' and 'storytelling' through making images that is so characteristic of their work in the early years in school. Most children will want to tell you about their painting or model, describe it to you, explain its meaning and why it has been made. At this stage it is more important to consider what the child has to say about his or her painting and the kind of thinking that has gone into it than the manner in which the observations have been recorded. You can show children that you value their work and their opinions by listening carefully to what they have to say about their work and by responding positively to their observations.

When five- and six-year-olds are making their 'storytelling' drawings you can help them by listening to the commentary that so often accompanies the drawing, by asking them questions about the work and by gently suggesting extensions to the drawing where this is appropriate.

A marked characteristic of good teaching in Art is the way that you can establish with individual children a continuous dialogue about their work as it progresses. The dialogue may consist of a mixture of exchanges between you and the child: some searching, some encouraging, some prodding, some straightforward exchanges of information.

When children are making their first drawings from observation the dialogue will be a fairly simple one and will be concerned mainly with ways of looking carefully, ways of using materials, ways of making different kinds of marks:

> Is it really that shape?
> Is it curved or straight?
> Where will you need to use the pencil very lightly?
> How are you going to make that pattern?
> What colour do you need to use there?

The nature of the questioning and the dialogue and talk that it might generate between children, as well as between teacher and child, will depend upon the kind of task the children are responding to. Dialogue and discussion about making a drawing from observation is mainly about looking – technical matters are supportive to the looking. Discussion about making a clay tile will be mainly about technical matters – about working and using clay in a particular way. Dialogue about making a drawing or painting of something recollected or a dream is mainly about notions, ideas and memories.

When helping children to appraise their work in Art it is important to relate the appraisal and the talk closely to the task and to be as specific as possible in seeking agreement with them about what they have achieved within the task. If children are to be encouraged to reflect upon their work effectively it is of little value or use to them to be told that their painting is 'nice' or 'interesting' or 'quite good' or 'a bit careless'. Dialogue about the work needs to be specific to the task and to what has been achieved within the task. Where the task has been properly focused through the initial talk and discussion then dialogue and appraisal should follow naturally. When the task is about observing and matching and making the colours seen in a collection of autumn leaves then the appraisal will be about such things as how well the shapes have been observed, how well the colours have been differentiated, how the materials have been used etc.

In the early years all such talk and dialogue should be used to familiarise children with the routine of describing what they have made in their work in Art and how they have made it. Talking with them about their work and giving it value plays an important part in developing their understanding of the purpose of their making.

As they grow in confidence in describing and appraising their own work and develop an appropriate art vocabulary for this, it will be possible to introduce more complex dialogue and to encourage them to review the progress of their work and to consider how their intentions have been realised in the work.

In **Key Stage 2** , in sharing work in painting with children, you may begin
to use such questions as:

> Which part of this painting are you most satisfied with?
> Can you find another way of using paint to make the kind of surface you want?
> How can you change the mood of this painting by using different colours?
> How has this painting changed since you began to make it from your first drawings?

It is comparatively easy to assess with children what they have achieved where the work is mainly concerned with description of things that you have seen and shared with the children. Where the tasks are more

personal and complex and, as with older children, where they are taking more initiatives and personal decisions themselves, then the dialogue and the reflection become necessarily more complex. The following questions are those that might be asked of a child in Year 5 or 6 who is nearing the completion of a longer and more complex piece of work:

> Does it satisfy you in terms of what you set out to do?
>
> Can you suggest alternative solutions to some of the problems you are solving?
>
> Have you chosen the materials for consideration of what they will do?
>
> Have you recognised or made any important discoveries in this work?
>
> Are you satisfied with the results?
>
> Has making this work given you further ideas you want to develop?

Children's developing ability to talk about, describe and reflect upon their own work will depend upon your giving them structured opportunities to do just this. In addition, they will need to learn and use an art vocabulary as they progress through the school and have every opportunity to compare and make connections between their own work and that of other artists, craftworkers and designers.

DEVELOPING AN ART VOCABULARY

In order to talk about and reflect upon their work in Art and Design children need to learn and use an appropriate vocabulary. As in all subjects and disciplines, Art and Design has its own vocabulary of terms that are used to name and describe specific tools, methods and processes, different kinds or schools of work and, perhaps most importantly, different qualities of visual appearance.

Attainment Target 1: 'Investigating and Making' refers to children working with a range of materials, tools and processes and *the visual elements of Art and Design*. The visual language of Art and Design is that range of visual elements and qualities that enable us to identify and discriminate between all those things we see in the natural and made environment. It includes such obvious qualities as colour line, pattern, shape, surface etc. Children can learn how to make and match and use colour: in order to do this effectively they have to be able to talk about and describe colour and differentiate between colours.

It is important, therefore, to seek ways to help children acquire sufficient art vocabulary to be able to talk about and reflect upon their work with confidence and increasing authority. An art vocabulary begins within that family of making, describing and responding words that children will use from their earliest years to describe what they are doing, what they see and what they think about what they see.

The first making words that children use may be specific to Art and Design — as are painting, drawing, modelling, printing, colouring etc. — or more generally descriptive of making — as in folding, bending, joining, scratching and pressing. Appropriately, you can introduce them to making words that distinguish between the different processes in Art and Design and that will identify, for example, that there are different kinds of printing processes: that you can make a 'press' print by cutting into or incising the plate, that a printing plate made from paper and card is a relief print and that screen printing is an extension of stencilling.

In your work with children in making drawings from observation there will be rich opportunities to encourage children to use a wide range of describing words to focus their attention upon the visual qualities of natural and made forms. As children move from describing to comparing and analysing then it will be possible to introduce a more specific art vocabulary to help them describe the visual qualities they see and use in their work and to use such specific terms as shade, tone, contrast, surface, weight, line and mass.

It is important to encourage an accurate use of the language of colour from the beginning and to teach children to use the proper names for colours, to distinguish between a vermilion (orange red) and a crimson (blue red) and to be able to identify the different blues that we use in schools. The standard watercolour box with its collection of exotically named colours — chrome and gamboge yellow, burnt sienna, prussian blue, raw umber and ivory black — presents opportunities for interesting discussion about the names of colours and their sources.

As they move through the school children should be encouraged to use the proper names for the tools and processes. Many of these will become more familiar when children are asked to make notes or working drawings to explain how they have designed things, just as they use similar methods to explain experiments and investigations they have undertaken in Science.

Through their work in Attainment Target 2 and in conjunction with their work in History they will become familiar with a wide range of different kinds of art, craft and design from different times and cultures. They will be able to identify different methods, materials and processes in the work of others — know the difference between a tapestry and a weaving, between a work of sculpture that is carved and one that is modelled, between a painting in oils and one in watercolour.

They should also be able to recognise that works made for different purposes have different conventions or appearances, that a sketch is different to a cartoon, that paintings may take such different forms as still life, landscape, portrait or interior and that masks, icons and posters all have different and particular functions in society. There will also be real opportunities for developing the children's art vocabulary in that work that links Attainment Targets 1 and 2. They will begin to make comparisons and connections between their own work and that of other artists and designers.

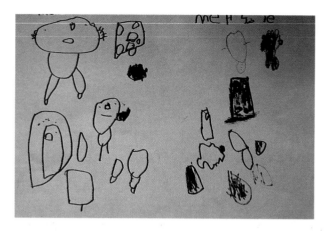

6.1 to 6.4 MY POST PERSON: VAN GOGH'S POSTMAN

Comparative drawings of the local postman/woman and postman Roulin by Vincent Van Gogh. The drawings of the local postperson were made first, from recollection. Van Gogh's postman was drawn from study of the drawing made by Van Gogh in 1888.

MAKING CONNECTIONS

When children are encouraged to compare and contrast their own work with that of others, they will begin to make those connections between their own work and that of other artists, craftworkers and designers that are important to their understanding of the context within which their work is made. This work can begin through such simple means as comparing their drawings and paintings of familiar subject matter with those made by other artists. Figures 6.1 to 6.4 illustrate the way that children in one school were encouraged to compare their own drawings of the local postperson with the drawing of postman Joseph Roulin made by Vincent Van Gogh in 1888. In making these drawings the children were drawn into discussion about the way that Van Gogh made a drawing, what materials he used and how he used different kinds of lines and marks in different parts of the drawing: their own understanding of drawing became more informed through making these kinds of observations and comparisons.

There are many ways in which children can be drawn into discussion about and appraisal of the work of others and into making comparisons between the work of different artists. In making a straightforward pastiche or copy of another work they will need to consider how that artist used and applied colour. Comparing the way that different artists have dealt with the same subject matter – as, for example, in contrasting a painting of mother and child by Mary Cassat with any Renaissance painting of the Virgin and Child – will generate discussion and appraisal and reasons for personal likes and dislikes of different kinds of work. Another useful teaching ploy is to describe a painting to children, ask them to make a drawing from your description and then compare their versions with the

original work (see figures 6.7 and 6.8). You can reconstruct for children the appearance of certain kinds of paintings in the classroom – for example, in arranging before them the objects which they can observe in a still-life painting or by having children dressing up and posing to recreate a portrait or family scene. Use the contrast between the painted image and the real thing to generate interesting appraisal of the way the artist has interpreted the theme.

Comparing and contrasting the way that artists working in different cultures have responded to similar subject matter is a particularly rich resource for generating discussion and debate about the appearance and meaning of works of art and craft.

(The different methodologies you can use to stimulate talk about and appraisal of other artists' work is dealt with in greater detail in *Knowledge and Understanding in Art*.)

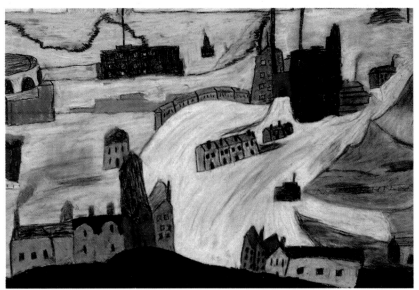

6.5 COMING FROM EVENING CHURCH
Year 5
Coloured pencils and pastel
Study from the painting 'Coming from Evening Church' by Samuel Palmer, 1830.

6.6 INDUSTRIAL LANDSCAPE
Year 4
Charcoal, chalks and pastel
Study from an industrial landscape by L S Lowry (1887–1976)

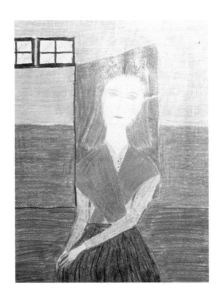

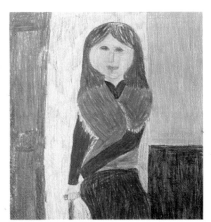

6.7 and 6.8 SEATED FIGURE
Year 4
Pencil and crayon
Drawings made in response to an oral description by the teacher of a painting by Amedeo Modigliani (1884–1920).

6.9 CHILDREN POSING TO RECONSTRUCT FIGURES IN THE PAINTING 'THE GLEANERS' BY JEAN-FRANÇOIS MILLET (1814–75).

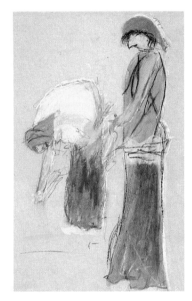

6.10 'THE GLEANERS'
Year 5
Charcoal and pastel

ORGANISING REFLECTION AND APPRAISAL

There are a number of ways in which you and your colleagues can structure positive opportunities for children to reflect upon and share with you the appraisal of their work. These will help you to put in place in your school the more systematic and frequent appraisal of children's work in Art and Design that is required by the National Curriculum. Much of this can be achieved by building upon existing good practice in Art and in other subjects.

Finding time

Giving children time and opportunities to reflect upon their work is an important element in developing in your school the good habit of sharing work. Many schools already do this by encouraging children to share their work with others through making presentations at assemblies. In **Key Stage 1**, the average amount of time spent on art and design activities is two hours per week: in **Key Stage 2** it is one hour 40 minutes per week. In many schools, most of that time is spent on actually making images and artefacts and comparatively little time on discussing with the children the progress and development of their work.

It is therefore a comparatively simple matter to consciously allocate more time for group discussion about the work in progress. From the earliest years in school you should establish the practice of talking about and sharing work at the end of each working session. The roots of good reflection lie in the way the initial task is set and how it is framed for the children through good talk and discussion about the task and the resources that support it. Where children have a clear view of the purpose of their work they are more able to reflect upon its progress and what they might have achieved.

Such sharing can begin in Reception and Year 1 through the familiar practice of laying out at the end of the session some of the work the children have made and through questioning to encourage them to comment upon their work and to consider what has been achieved. As children grow in confidence and as their work becomes more complex it will be necessary to allocate more time for this reflection and review.

Time spent on discussing and reviewing work with children, both individually and in groups, is time well invested and will contribute significantly to their ability to understand and reflect upon their achievements.

Artwork books

Introducing to children the notion of keeping an artwork book can be supportive to their thinking about their work and is a useful and pragmatic way for them to put together evidence of their progress in their work in Art and Design. All artists and designers keep notebooks or sketchbooks. They use them to record not just their drawings, but also a wide range of other reference material including notes and comments about things they have seen and collections of photographs and reproductions of works of art and design that particularly interest them.

Keeping an artwork book, sketchbook, notebook, diary – call it what you will – is a valuable way for children to keep track of what they have made in Art and Design, what references and resources they have used and how their ideas and thinking have developed. An artwork book might include the following:

● drawings
● photocopies of drawings and paintings made by the children
● photographs
● reproductions of works of art and design
● comments and notes about things they have seen
● sketches and working drawings for things they want to make
● notes on technical processes
● personal comments about things they have made
● descriptions of things they have made.

In keeping such an artwork book, children are also able to take evidence of their interests and achievements in the subject from teacher to teacher as they progress through the school.

Writing about Art

The suggestions above for what might be put in an artwork book include examples of children's writing about their work. They can make notes about technical processes and describe and comment upon their own work.

In writing about the work they have made, children are immediately involved in making some kind of appraisal of their achievements. Such writing and note taking is now common practice in the teaching of Science in the National Curriculum, where children write about and comment upon their investigations and experiments and draw conclusions from these. There are, similarly, useful occasions for children to comment upon what they have made in Art and Design.

A child in Year 5 wrote the following description of making a drawing of a pheasant:

> 'We had art on Monday and we had to draw an animal, a dead one that had been stuffed and had come from a museum. Some people drew a fox, some drew a little rabbit and others drew butterflies under the microscope. I drew a pheasant. It was difficult in places when you had to make the colours. I drew the pheasant in cray-pas pastels because I could smudge and rub the colours together. I had to look carefully and study hard to get the texture of the feathers and the shape of the bird. I enjoyed drawing the pheasant as it was colourful and lifelike. While I was drawing the pheasant I thought of when the pheasant was running free, eating and drinking in the wild.'

As well as writing about their own work, children will enjoy describing and commenting upon the work of other artists and using their language

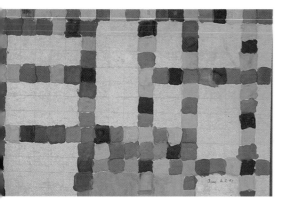

6.11 STUDY FROM 'BROADWAY BOOGIE-WOOGIE' BY PIET MONDRIAN (1872–1944)
Year 3
Tempera

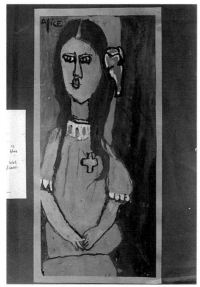

6.12 STUDY FROM 'ALICE' BY AMEDEO MODIGLIANI
Year 4
Tempera

6.13 CLASSROOM DISPLAY FOR A TUDOR PROJECT
Year 5

skills to explain their view of what other artists have made. Young children are open and honest in their comments upon the work of others and will very often show scant respect for reputation. Children in Year 3 made the following comments about paintings by Piet Mondrian and Amedeo Modigliani after they had made studies from the works.

> *'Broadway Boogie-Woogie' by Mondrian*
> 'Mondrian got the idea of "Broadway Boogie-Woogie" from a map of Broadway. I do not think it was easy to paint it because of the straight lines but I think it was a waste of time. I do not like it at all but it would be quite good on my bedroom wall because counting the squares would help me to get to sleep.'

> *'Alice' by Modigliani*
> 'I think Alice is sad. I think she has got a sad look on her face. Her eyes are slanted and they are brown. Her dress is pale blue and if I had this picture I would put it in my bedroom. My bedroom is white. I think she looks sad because she has a pursed up mouth. She is thinking very hard about something.'

In these examples, children were writing about paintings that they would choose to hang on their bedroom wall at home. In their writing they are both describing and commenting upon these works. There is a wide range of ways that children's writing about art can be placed in such different kinds of context as choosing work you would want at home and identifying works you particularly like and dislike. These are discussed further in *Knowledge and Understanding in Art*.

Encouraging children to talk and write about different kinds of work that is made for different purposes and in different kinds of context is valuable towards their developing both the vocabulary and confidence to make judgements about their own work and that of others.

The presentation of children's work

The way in which you display or present children's work can play a positive part in both reflection upon and appraisal of work in Art and Design. It is common practice to display children's work well in order to give it value and to make sure that all the work of the group is publicly presented at some stage in the term. Such displays will also remind children of what has been achieved within the work and will give them the opportunity to share and talk about their work with others.

Wherever possible, children's work should be displayed together with the resources and reference materials that generated the enquiry so that there are opportunities to use the display to discuss with the children the different ways they may have responded to the theme or starting point.

At times, the presentation can be used didactically to demonstrate the sequence and development of the work in progress, to show how ideas have emerged, what has been learnt and how images and artefacts have been shaped by the enquiry and the resources used.

Where children's work is presented and publicly shared, display can be much more than just a way of making the school look attractive: it can become an active agent in the children's learning and help them to understand what has been achieved by both themselves and others.

Sharing and identifying achievement

The introduction of the National Curriculum and the new practice of assessing each child's performance at the end of each Key Stage in all subjects will require you to identify more precisely than before the children's levels of achievement in Art and Design. At the end of each Key Stage you will need to identify the level at which children are working in Art and Design. It is assumed that by the end of **Key Stage 1** children will be working between Levels 1 to 3; by the end of **Key Stage 2** between Levels 2 to 5. You will need to share with colleagues the practice of reviewing children's work to observe their progress as they move from **Key Stage 1** to **Key Stage 2**.

Earlier (figures 6.1 to 6.4) there were some examples of children's drawings of postmen and women. These are some of the drawings made by all 64 children in a school on the same day, after they had passed the drawing by Van Gogh from class to class. This provided the teachers in this school with an opportunity to share and compare drawings of similar subject matter made by all the children and to see how their drawing was progressing as they passed through the school.

(The reviewing of children's work in progress and the identification of their levels of achievement are discussed in detail in Chapter 7.)

Such sharing and review of work is valuable for you and your colleagues, helping you to become more familiar with the stages of development in children's work and how their work progresses.

In Art and Design, differentiation is achieved through assessing the way that children respond at different levels to a common task. In secondary schools, there is a long tradition of moderating children's work through concensus meetings where a number of teachers will review the work from a number of schools to agree upon levels of achievement set against agreed criteria.

The National Curriculum will require you and your colleagues to similarly share and review children's work in your own school so that you can monitor progression and achievement in Art throughout the school. It makes sense to begin by sharing children's response to familiar and simple tasks such as making a self-portrait or drawing from everyday natural and made forms. If you begin in this way you will find it comparatively easy to identify the different stages and levels of work. You will be surprised to discover how quickly you can become familiar with levels of achievement in Art, just as you are familiar with levels of achievement and progression in language.

In Art and Design, it is important to remember that assessment is always constructive. It serves to help children to understand the progress they are making and you to see what stage of development and capability they have reached in order that you can plan further work to build upon and further their achievements.

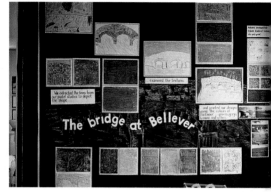

6.14 CLASSROOM DISPLAY: THE BRIDGE AT BELLEVER
Year 4
Showing the development of work from first drawings into print making.

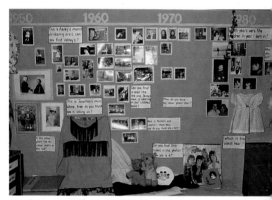

6.15 CLASSROOM DISPLAY: HISTORY PROJECT
Year 4
Timeline display, 1950–1980.

6.16 CLASSROOM DISPLAY: TECHNOLOGY PROJECT
Year 6
Designing for a dinner party. Showing the development and progress of work.

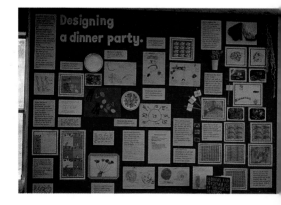

7 Identifying and recording children's levels of achievement

USING CRITERIA TO IDENTIFY LEVELS OF ACHIEVEMENT

The introduction of the National Curriculum in Art requires that children's work should be assessed at the end of each Key Stage. In Art, as in Music and P.E., the assessment is to be descriptive and based upon the End of Key Stage Statements for each of the Attainment Targets. A.T. 1 'Investigating and Making' carries twice the weight of A.T. 2 'Knowledge and Understanding'.

Although it is not statutory that you should identify children's levels of attainment on the scale of 1 to 10 as in all other National Curriculum subjects, you will need to have some sense of their levels of achievement compared with that in other subjects if you are to inform parents of their children's progress in art against national standards as required.

This chapter is, therefore, concerned with identifying both the criteria by which you can assess children's work in art and how such criteria might relate to their development and progression through different stages in their work.

What is meant by levels of attainment?

In all subjects, other than Art, Music and P.E., you have to assess children's levels of attainment at the end of **Key Stage 1** and **Key Stage 2** by numerical scale as follows:

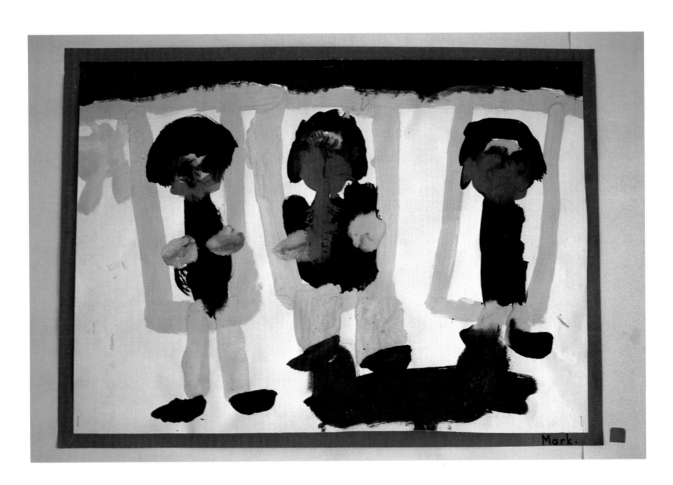

Levels of attainment

Key Stage 1		1	2	3		
Key Stage 2			2	3	4	5

This means that the average level of attainment in Art at the end of **Key Stage 1** will be at Level 2 and at the end of **Key Stage 2** at Level 3/4. You will find it useful to use a similar notation to identify children's achievements in Art and Design so that you and your colleagues can have a shared view of what constitutes progression and achievement in their work in art as in other subjects.

In the National Curriculum in Art, you will have to use the End of Key Stage Statements for each of the Attainment Targets as the framework for your assessment of the children's work. Each of these statements describes what the children should have experienced in each of the principle strands of the art curriculum as follows:

A.T. 1 INVESTIGATING AND MAKING

Key Stage 1	**Key Stage 2**
a) Represent in visual form what they observe, remember and imagine.	Communicate ideas and feelings in visual form based on what they observe, remember and imagine.
b) Select from a range of items they have collected and use them as the basis for their work.	Develop an idea or theme for their work, drawing on visual and other sources and discuss their methods.
c) Work practically and imaginatively with a variety of materials and methods, exploring the elements of Art and Design.	Experiment with and apply their knowledge of the elements of Art choosing appropriate media.
d) Implement simple changes in their work in the light of progress made.	Modify their work in the light of its development and their original intentions.

A.T. 2 KNOWLEDGE AND UNDERSTANDING

Key Stage 1	**Key Stage 2**
a) Recognise different kinds of art.	Identify different kinds of art and their purpose.
b) Respond to art from a variety of styles, times and cultures.	Begin to identify the characteristics of art in a variety of genres from different periods and cultures and traditions, showing some knowledge of the related historical background.
c) Begin to make connections between their own work and that of other artists.	Make imaginative use in their own work of a developing knowledge of the work of other artists.

These end of Key Stage Statements describe the various experiences and activities that children should receive in their Art education in **Key Stage 1** and **Key Stage 2** These are process based as in Technology,

and although there is some description of content as in listing the elements of Art and Design that children should study in the Programmes of Study for A.T. I, they are generally content free. This means that when you assess their work at the end of each Key Stage, you will have to decide at what level of quality the children have satisfied the requirements of the Attainment Targets and their attendant Programmes of Study.

Work in Art and Design is not content specific: making a self-portrait or a landscape painting are activities that are equally appropriate at different stages in the artist's life whether undertaken by a child of 5 or by an artist in maturity. Differentiation in Art and Design has always been achieved by assessing the level of quality at which children and students respond to a common task.

This will mean, for example, that at the end of **Key Stage I**, you will need to be able to decide whether a child is making and using colour at Levels I, 2 or 3 and at what level they are recording the appearance of natural and made forms. In order to do this you will need to become familiar with and be able to use and apply those criteria that describe achievement in specific experiences within Art and Design.

Within your school, you will need to share and review children's work with your colleagues in order to begin to identify, for example, what is a Level 2 or a Level 4 achievement in different aspects of Art and Design. You will obviously be appraising a body of work by each child at the end of each Key Stage. Your assessment will be informed through knowing about how their work has developed or changed over a period of time and as they move from year to year.

In order to become familiar with levels of achievement in Art, it will be useful to begin by looking with colleagues at different children's work. It makes sense to begin by looking at the way children have responded to a common task, as in the making of a self-portrait.

The pattern and development of children's image making was described in some detail in chapter 2. It was illustrated by looking at the way that children's drawings of such familiar things as people, houses and birds develop and change as they progress through school. In drawings of their friends and of houses near the school, you can see how children progress from using simple shapes to making fully descriptive drawings where they give great attention to detail and attempt to place the figure or house in space (see figures 7.1 to 7.10).

These drawings and paintings are characteristic of the range of achievement you will find in work undertaken by children in **Key Stage I** and **Key Stage 2**. You could use such collections as the basis for discussion with colleagues in order to differentiate between the work and to begin to identify to which level of achievement they correspond.

Examples of criteria

Figures 7.1 to 7.10 show a selection of drawings by children of people and houses (from chapter 2). On the following page is an outline of the

criteria used to identify the level of achievement in each work. These examples indicate the kinds of review of criteria that will emerge from discussion with colleagues. Once the criteria have been established, you will be able to place examples of children's work at the appropriate level of achievement.

Figure	Level	Criteria
7.1	1	Figures drawn symbolically, using simple shapes to describe the body, head and the features of the face.
7.2	1	Standard symbol for the 'first' house – box with triangle for the roof. Bottom of paper used as baseline and the sky a strip of colour at the top of the page.
7.3	2	Figures drawn symbolically using simple shapes but with more attempt to differentiate between features and with real attempt to describe the different hairstyles.
7.4	2	Shape of the house and some features drawn symbolically. Very real attempt to describe patterns of roof tiles, bricks and garage door.
7.5	3	Although some features of the figure are still drawn as symbols (mouth and eyes) there is good evidence of attention to detail in the description of the hair, the proportions of the figure and the detail of clothes.
7.6	3	Some aspects of the houses are drawn symbolically; in others there is differentiation between colours and patterns of roofs and pavements. Attempt to explain the houses three dimensionally by showing front and side and using diagonals to explain the position of the houses in the road.
7.7	4	Careful mapping of the shapes of the head and features. Attention to the way that the hair grows and its different colours. The tracksuit and badges are detailed.
7.8	4	Real attempt to place a row of houses in space and to show that they are solid forms. Lots of attention to the detail of window frames, door porches, television aerials, garden paths and fences.
7.9	5	Good description of proportions of head and features and of their three-dimensional qualities (the ears are in place behind the cheek bones, the collar encircles the neck). Subtleties of colour change in the hair, flesh tones and pullover are effectively described.
7.10	5	Good description of the solid form of a house. Very careful attention given to explaining the three-dimensional form of the porch and bay window. Shapes and patterns of windows and of door furniture are carefully observed.

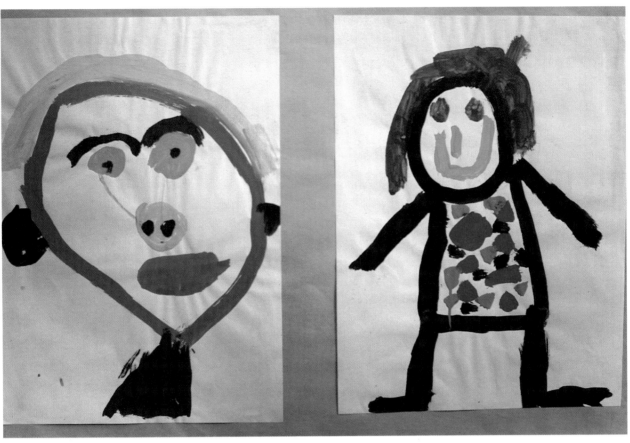

7.1 PEOPLE
Reception
Tempera

7.2 A HOUSE
Reception
Crayon

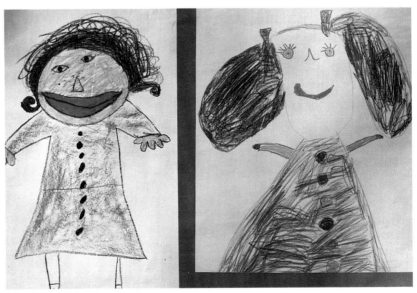

7.3 PEOPLE
Year 1
Crayon

7.4 HOUSES
Year 1
Pencil

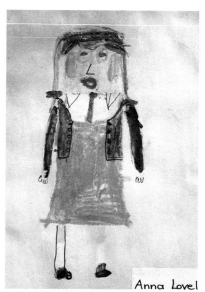

7.5 GIRL
Year 3
Crayon

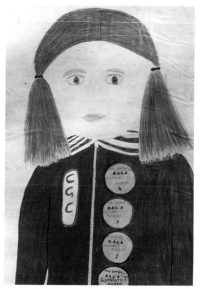

7.7 GIRL
Year 5
Coloured pencil and pastel

7.6 HOUSES
Year 4
Felt pen

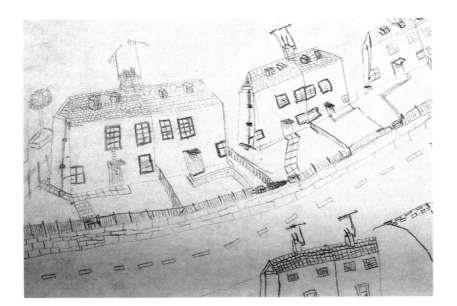

7.8 HOUSES
Year 5
Pencil

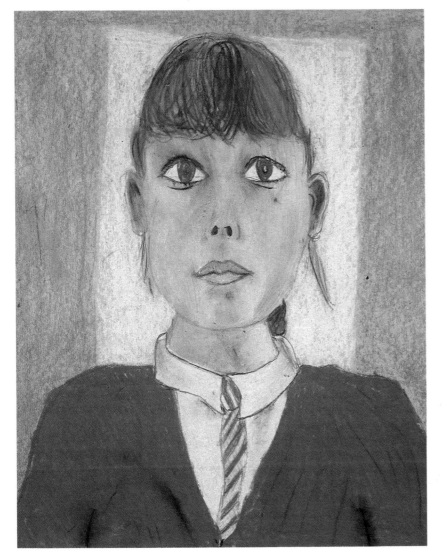

7.9 GIRL
Year 6
Pencil and pastel

7.10 HOUSE
Year 6
Tempera and pencil

These portrait drawings and paintings are characteristic of that range of achievement that you will find in work of this kind undertaken by children in **Key Stage 1** and **Key Stage 2**. You could use this collection of drawings as the basis for discussion, to begin to differentiate between them and to identify to which levels of achievement they correspond.

Drawings of seagulls at different levels of achievement

Figures 7.11 to 7.13 show drawings of seagulls made by children in Years 1 and 2. They are typical of the kind of drawings that children will make from observation of animals and birds. You could differentiate between them and identify their levels of achievement as follows:

Figure	Level	Criteria
7.11	1	Has used shapes and symbols to 'name' different parts of the seagull: head, body, beak, eye etc. Has attempted to describe the feet; has used colour to identify the head.
7.12	2	Has given some attention to shape and proportion of body and head; has used colour to differentiate between some parts of the body. Is beginning to describe some parts of the bird in detail.
7.13	3	Has given careful attention to detail and to shape and proportions of head, body and tail. Has used colour to describe different parts of the bird's body.

Drawing from recollection

In looking at children's work in this way you will begin to identify criteria for assessment which are the means for describing what children have achieved in their work. You will find yourself using different criteria when looking at different kinds of work. The descriptions in the previous section relate to making drawings from observation: those in figures 7.14 to 7.17 relate to drawings made from recollection and speculation about the appearance of the local postman or lady.

7.11 SEAGULLS
Level 1
Chalk and crayon

7.12 SEAGULLS
Level 2
Chalk and crayon

7.13 SEAGULLS
Level 3
Chalk and crayon

Figure	Level	Criteria
7.14	1	Using symols to name and identify different parts of the postman/lady and their possessions. Detail is much more important than scale.
7.15	2	Still using shapes and symbols but more attempt to describe 'important' features such as letters, postbag and hats. Clear differentiation between hairstyles of the three postladies. Some attention to shape and proportion of heads and bodies.
7.16	3	Similar representation of figures to previous example plus attempts to place the figure in space or in a setting: e.g. the postman's van is drawn in three dimensions, the postman is shown in front of the postbox whose door is open in front of the house.
7.17	4/5	Attention given to detail and character of the postman or lady and to shape and proportions of heads and bodies. Figures are placed in space and context and with reference to the house they are visiting, e.g. gate and friendly dog.

7.14 LOCAL POSTMAN AND LADY
Level 1
Fibre tip pen

ASSESSING LEVELS OF ACHIEVEMENT

There are many familiar themes and subject matter that you and your colleagues will use with children as they make their way through your school. During their primary school years, children will return to and work from the same subject matter at different stages of their schooling. Children will make drawings and studies of themselves and their friends, of familiar plants and of the local environment many times and for different reasons. Each time they return to such familiar source material for their work, they will respond at different levels of perception and maturity. This returning to and use of common content at different stages of their schooling provides you with good opportunities to review and compare the different levels of response that children can achieve in their making of images and artefacts as they progress through the school. It also allows you to become more proficient at 'reading' the different stages in their development.

7.15 LOCAL POSTMAN AND LADY
Level 2
Fibre tip pen

7.16 LOCAL POSTMAN AND LADY
Level 3
Fibre tip pen

7.17 LOCAL POSTMAN AND LADY
Levels 4/5
Fibre tip pen

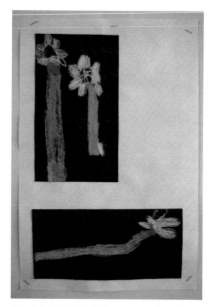

7.18 DAFFODILS
Year 2
Chalk and crayon

7.19 A PLANT
Year 2
Chalk and crayon

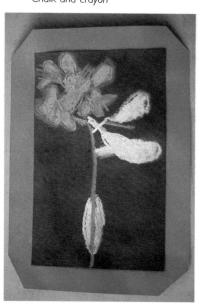

The examples in figures 7.18 to 7.22 illustrate how you might review and assess children's achievements in their making of images in response to making studies from familiar source material such as plants and the local environment.

Drawings of plants at different levels of achievement

Figure	Level	Criteria
7.18	1	Head of daffodil drawn as a flat pattern of petals all similar is size and shape. Stem is drawn as a simple column. Simple naming of colours.
7.19	2	Some differentiation between shape and size of petals and some colour variation. The stem is shown in proportion to the size of the plant head.
7.20	3	Careful attention to detail of petals, stamen and stem. Differentiation between shape of leaves and thickness of stems. Attempt to record variations in the colour of the petals and leaves.
7.21	4	Proportion of flowers and stems well observed in relation to the plant container. Some subtlety in the use of colour. Flowers are observed in space through use of overlapping. The vase is made solid by recording reflected light on its surface.
7.22	5	Poinsettia confidently and freely recorded, with bold use of shapes and of dark and light colours to give the plant a strong three-dimensional quality. Subtle use of colour variation within the leaves and petals.

Drawings and paintings of the environment at different levels of achievement

This group of work is from a variety of environments and includes some work made directly from observation, some from recollection and some from drawings and notes made in the environment. There is, therefore, a wider range of criteria to consider than when assessing work made entirely from observation or entirely from recollection.

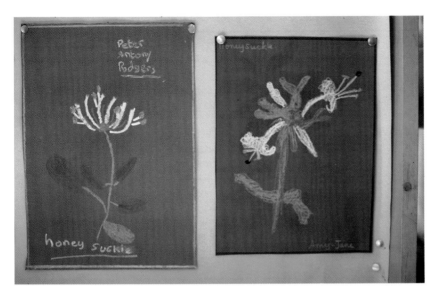

7.20 HONEYSUCKLE
Year 4
Chalk and crayon

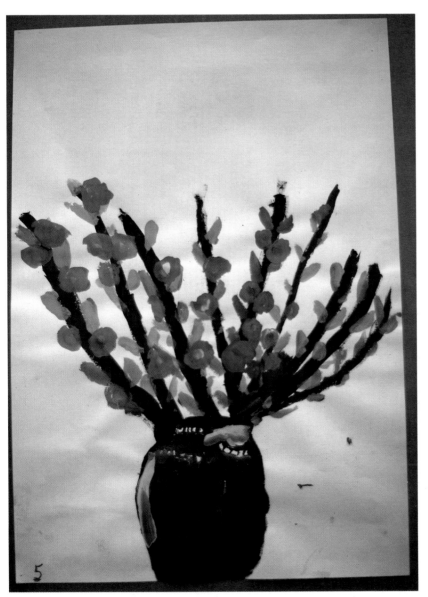
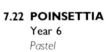

7.21 TWIGS IN A POT
Year 5
Tempera

7.22 POINSETTIA
Year 6
Pastel

7.23 SWINGS IN THE PARK
Year I
Tempera

Figure	Level	Criteria
7.23	*A I	The three children playing on the swings in the local park are represented as three nearly identical symbols; the colour is used arbitrarily, simply as a means to draw the shapes.
7.24	I	In this painting from the imagination of a child playing with a dog in the sunshine, the story is represented simply and vigorously using simple shapes and abitrary colours to describe the event.
7.25	2	Although the children playing on the beach and in the sea are represented through simple symbols for the figures, there is some differentiation between them in their dress and in their gestures and activities. Colour is used arbitrarily to identify different things within the painting.
7.26	2	The details of the house and its garden are described through using simple shapes for parts of the house and the trees and plants. In addition, there is an attempt to describe the house in space by showing front and side view and by placing the garden round and behind the house.
7.27	3	This painting of boats at Clovelly is drawn from both local knowledge and observation of paintings by local artists. Although the figures are drawn very simply and symbolically, a lot of care is given to placing the boats on the beach and to explaining the space in the landscape.
7.28	3	In this watercolour of the local church and its surroundings, the church, tree and gravestones are described simply but there is subtle use of the medium to describe colour, pattern and surface in the environment.

*A I – means 'approaching Level I'

Figure	Level	Criteria
7.29	4	In this observation from the classroom window, careful attention is given to describing the classroom beyond and the landscape behind the school by the use of overlapping shapes and by recording features diminishing in size in the distance.
7.30	4	In this painting of boats in the harbour which was developed from drawings made during a visit, the shapes and surfaces of the boats have been carefully described and differentiated and placed in space. There is some subtle use of the media to make comparisons between different surfaces.
7.31	5	This watercolour painting of a cottage was developed from drawings and colour notes made in the environment. The drawing describes the subtle shape of the cottage and its detail. There is considered use of colour mixing to describe the range of colours in the building and its environment.
7.32	6	This painting draws upon experience of a walk along a cliff path and notes made during the walk and upon observation of maritime paintings by other artists. The pigment is used with confidence and vigour to convey the dramatic atmosphere of the landscape. There is subtle use of colour mixing and contrast of surface to describe the features within the landscape.

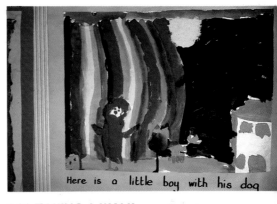

Here is a little boy with his dog

7.24 TAKING A WALK
Year 1
Tempera

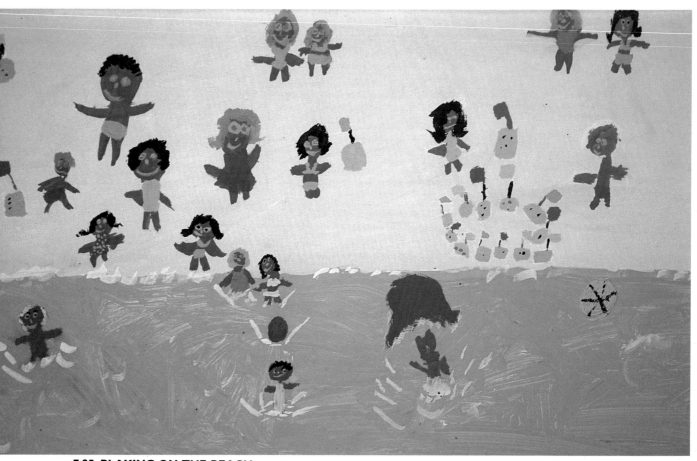

7.25 PLAYING ON THE BEACH
Year 2
Tempera

7.26 HOUSE AND GARDEN
Year 2
Crayon and felt pen

7.27 BOATS ON THE BEACH
Year 2
Crayon and tempera

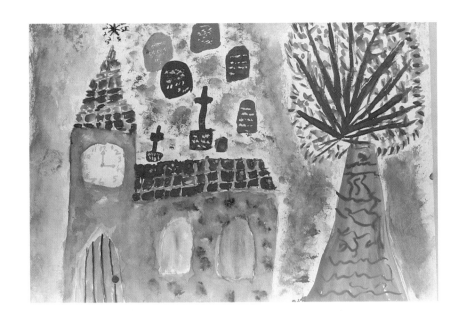

7.28 CHURCHYARD
Year 4
Watercolour

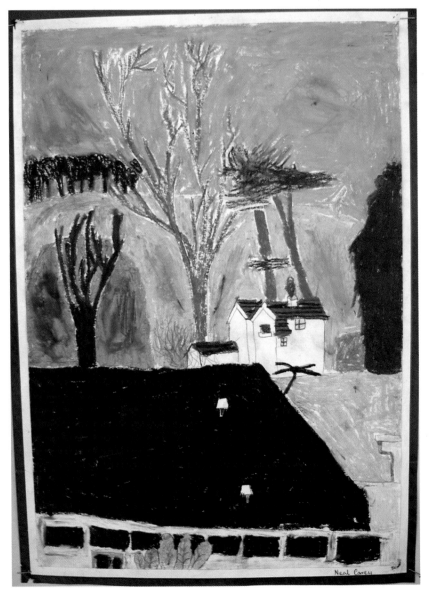

7.29 VIEW FROM THE CLASSROOM
Year 5
Tempera and pastel

7.30 HARBOUR
Year 5
Tempera

7.31 COTTAGE GARDEN
Year 5
Watercolour

7.32 SEASCAPE
Year 6
Tempera

REVIEWING OTHER WORKS

If you were similarly reviewing different kinds of paintings or work in print making or one of the crafts, then other criteria would come into play as you look for ways to differentiate between children's achievements and to identify at what level they are working.

Still life

In looking at still-life paintings made from observation, you would need to consider the following criteria:

- How well the colours are made and matched to those in the group observed.
- How sensitively and with what variety the medium is used.
- How colour is used to explain the surface of objects in the group.
- How the space occupied by the group is described.
- How thoughtfully the view has been selected and placed upon the page.

Print making

In considering work in print making you would need to consider the following criteria:

- How the preliminary drawing was used to explore the idea or content for the print.
- How the design was selected from the drawing and research.
- How the design has been translated into the media for the print.
- How efficiently the printing block or plate has been made.
- How well the prints have been taken from the plate.
- How the design has been modified or developed as the prints emerge.

There are further examples of the criteria to be used in assessing work in paintings and crafts and examples of levels of achievement in children's work in Part 11 of *Investigating and Making in Art*. The use of such criteria will also be part of your teaching and dialogue with children about the progress of their making. It will form the basis for much of the discussion that you will have with children about such qualities as their work emerges.

A CHECKLIST

Because the Programmes of Study for Art and Design encompass a range of activities and processes, you will find it useful to keep a checklist of these, both to assist you in planning coherent programmes of work with the children and in preparation for assessing their work across a range of art and design activities.

Checklist of art and design activities and processes
Attainment Target 1: Investigating and making

Investigating	Draw from direct experience of the natural and made world.
	Draw from memory and imagination.
	Select and use reference and resource materials.
Making	Use a range of materials, tools and techniques in painting and in two- and three-dimensional design.
	Explore and use a range of visual elements: colour line and tone pattern and surface shape and form.
Reviewing	Talk about own work and that of others.
	Use an art vocabulary.

Attainment Target 2: Knowledge and understanding

	Use other artists work to inform their own work.
	Know about different kinds of work by other artists and why it is made.

You could use this summary of the principle components of the National Curriculum in Art as a checklist for your own use and to ensure that you are providing a balanced programme of work for the children. All you need to do is review at the end of each class project or at the end of each term how many of these components have been addressed and take account of the balance in planning work for the next project or term.

You could also use a simplified version of this checklist as a means of recording the work and progress of individual children, both within your class and throughout the school. How much you would need to include on an individual record card for Art and Design would depend upon the

circumstances in your own school and its assessment policy.

A simple version might be used in Key Stage 1 or in a small school where the children stay with the same teacher for two years at a time and where an assessment summary is made at the end of each academic year. Such an assessment profile would be a useful means of keeping track of a child's work from year to year and for informing Key Stage assessment when it takes place at the end of Years 2 and 6.

The examples below and overleaf have been completed to show comparative comments for children in both **Key Stage 1** and **Key Stage 2**. There are blank versions on pages 123 and 124.

Key Stage 1

NAME: John Smith Age 7. 4 Level 2

AT 1
INVESTIGATING

He is beginning to look more carefully and to appreciate the importance of keeping notes and sketches for future use.

MAKING

He is using a good range of tools and materials. He enjoys painting and drawing and uses initiative in finding out how to do things. He needs to be more patient and careful with his three-dimensional work.

REVIEWING

He is showing more confidence in talking about his work and is beginning to use an art vocabulary.

AT 2
USING ARTISTS' WORK

John has enjoyed using works of art to borrow ideas for using colour and pattern. He is able to understand how using brush marks affects the appearance of a painting.

KNOWING ABOUT ARTISTS' WORK

He has three favourite artists and a collection of post cards of their work. He is keen to find out about other artists who work in a similar way.

Key Stage 2

NAME: *Helen Jones* Age *10.8* *Level 4*

AT 1
INVESTIGATING

Helen has a good grasp of how to select and record images she wants to use in her work. She is able to work at different aspects of a subject on her own initiative.

MAKING

Growing confidence is evident and she now has an appreciation of the time and effort needed both on her painting and craft work.

REVIEWING

Her ability to analyse her own work has increased and she is able to discuss different ways she might tackle a project and why she chose a particular solution.

AT 2
USING ARTISTS'
WORK

Helen took some time to realise how useful it was to study other artist's work. She is now enjoying analysing paintings to help her with her own compositions.

KNOWING ABOUT
ARTISTS' WORK

She is interested in learning about other artists and talks and writes well about those whose work she particularly enjoys.

It might be more appropriate to use a more complex version with older children or in a larger school, where children might be taught by several different teachers in **Key Stage 2**. An example of such a version is given on page 125. As a rule, it is sensible to keep any system of profiling as simple as possible within the assessment requirements of the National Curriculum in Art.

These kinds of assessment profiles should only be used as useful checklists when reviewing with colleagues children's work undertaken over a period of time. They may help you to keep in mind all the different aspects of work in Art and Design.

These are the various components that will contribute to a coherent programme of art and design teaching and to children's learning in Art. They should therefore be the matrix for recording and assessing the children's achievements in Art and Design.

Key Stage 1

NAME: Age

AT 1
INVESTIGATING

MAKING

REVIEWING

AT 2
USING ARTISTS'
WORK

KNOWING ABOUT
ARTISTS' WORK

Key Stage 2

NAME: Age

AT 1
INVESTIGATING

MAKING

REVIEWING

AT 2
USING ARTISTS'
WORK

KNOWING ABOUT
ARTISTS' WORK

NAME: Age Levels of achievement

AT 1

INVESTIGATING

Drawing from observation

Recollecting and imagining

Using resources

MAKING

Use of materials and processes

Use of visual elements

REVIEWING

Ability to review and modify work

Use of art vocabulary

AT 2

UNDERSTANDING

Use of other artist's methods
and systems

Making comparisons between own
work and that of others

KNOWLEDGE

How other artists make work

How artists communicate ideas

Bibliography

Adams, E and Ward, C, *Art and the Built Environment* (Longman 1982)

Art Advisers Association, *Learning through Drawing* (AAA 1976)

Barret, M, *Art Education: A Strategy for Course Design* (Heinemann 1979)

Clement, R T, *The Art Teacher's Handbook* (Hutchinson 1986)

Clement, R T (ed), *A Framework for Art, Craft and Design in the Primary School* (Devon LEA 1990)

Clement, R T and Tarr E, *A Year in the Art of a Primary School* (NSEAD 1992)

D E S, *The Curriculum from 5 to 16* (HMSO 1985)

D E S, *Art in Junior Education* (HMSO 1978)

D E S, *Art for Ages 5 to 14* (HMSO 1991)

Eisner, E W, *Educating Artistic Vision* (Macmillan 1972)

Gentle, K, *Children and Art Teaching* (Croom Helm 1985)

Gulbenkian Foundation, *The Arts in Schools: Principles, Practice and Provision* (Gulbenkian 1982)

Kellogg, *Analysing Children's Art* (National Press Books 1972)

Morgan, M, *Art 4–11* (Blackwell 1988)

N S E A D, *Art, Craft and Design in the Primary School* (NSEAD 1986)

Robertson, S, *Rose Garden and Labyrinth* (RKP 1963)

Robertson, S, *Creative Crafts in Education* (RKP 1963)

Schools Council, *Art 7–11* (Schools Council 1978)

Schools Council, *Resources for Visual Education 7–13* (Schools Council 1981)

Taylor, R, *Educating for Art: Critical Response and Development* (Longman 1985)

A NOTE FOR THOSE TEACHING IN SCHOOLS IN WALES

Teachers working in schools in Wales who use this publication will need to note the difference between the structure of Attainment Targets for Art in Wales as compared with that in England.

The Secretary of State for Wales accepted the original Attainment Target structure proposed by the Art Working group which was published in the Final Report 'Art for Ages 5 to 14' (DES 1991). This means that in Wales there are three Attainment Targets for Art:

AT1 Understanding
AT2 Making
AT3 Investigating.

In England, The Secretary of State for Education required that the number of Attainment Targets should be reduced to two:

AT1 Investigating and Making
AT2 Knowledge and Understanding.

The Programmes of Study for Art in England and Wales are, however, virtually identical though differently ordered. Their relationship is explained in the table below.

England	Wales
AT1 Investigating and Making	AT3 Investigating
1a	3a
1b	3b
	AT2 Making
1c	2a
	2b
1d	2c
AT2 Knowledge and Understanding	AT1 Understanding
2a	
2b	1b
2c	1a

The titles in this series should make it evident to teachers in both England and Wales which Attainment Targets are the focal points for the text in each publication.

Index